THE MUSIC OF
LEONARD COHEN

BY CHRIS WADE

THE MUSIC OF LEONARD COHEN
by Chris Wade

Wisdom Twins Books, 2016
wisdomtwinsbooks.weebly.com

Text Copyright of Chris Wade, 2016

All rights reserved. No part of this publication may be reproduced, stored in a retrieval system, or transmitted in any form or by any means, electronic, mechanical, photocopy, recording or otherwise, without prior written permission of the copyright owner. Nor can it be circulated in any form of binding or cover other than that in which it is published and without similar condition including this condition being imposed on a subsequent purchaser.

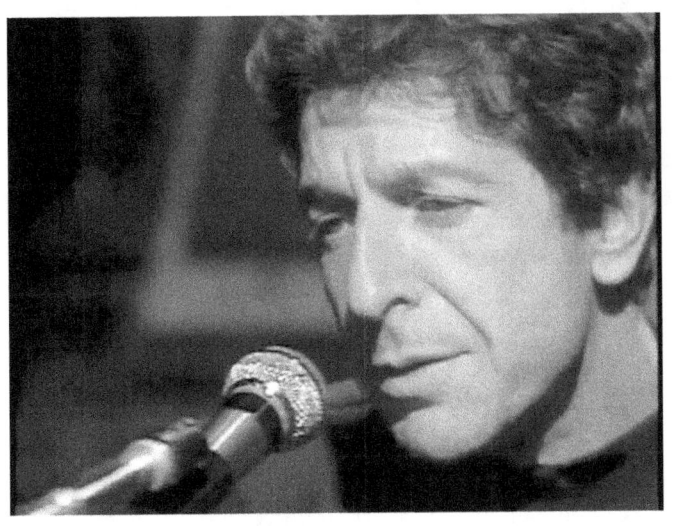

The Music of Leonard Cohen

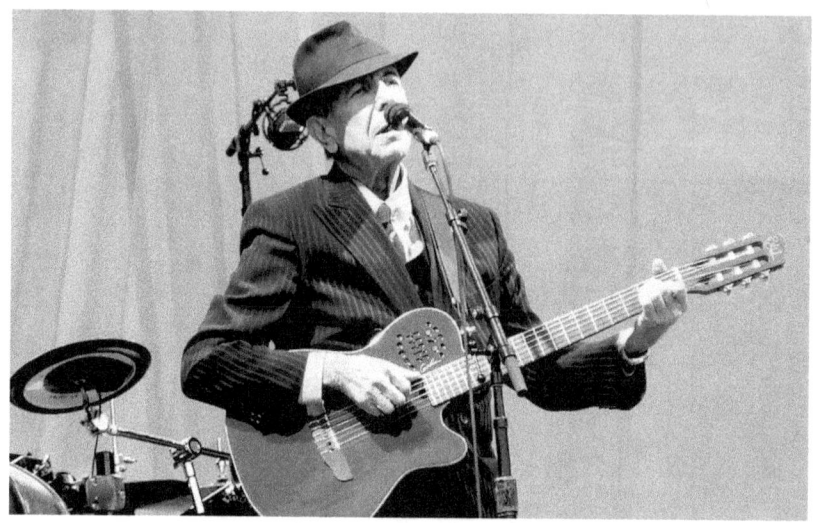

INTRODUCTION

Every Leonard Cohen fan can recall their introduction to his work with hazy nostalgia. Back when I was a kid for example, Leonard Cohen was a man on a few of my dad's old sampler records, a sharp suited, well dressed gent who looked a bit like Dustin Hoffman and spoke rather than sang. He was this supposedly depressing singer songwriter they made jokes about on The Young Ones; the kind of musician a serious grown up likes. Then I recall seeing a clip of him playing The Stranger Song on the Julie Felix show and watching his fingers moving so rapidly over the strings in amazement, as his face and body remained totally still, save his lips of course, from which beautiful, haunting words calmly appeared. Then there was the performance of Dance Me to the End of Love on the Jools Holland show, with an older Leonard oozing charm as he crooned between his female backing singers. Then of course, I picked up his debut LP, Songs of Leonard Cohen, from a record shop, totally sold by the crusty

cover and that serious face staring back at me. I took it home to my flat and entered into a secret world, a place only a certain kind of person can get comfortable in the solitude of; the world of Leonard Cohen.

After playing those songs over and over again - Suzanne, Teachers, Winter Lady, So Long Marianne - I came across an old dog eared copy of Beautiful Losers, his acclaimed 1966 novel. It was then I learned that Cohen first found fame as a writer and poet in his native Canada. He had moved to a house on Hydra, the Greek Island, a place with no electricity and only basic amenities, living the life of a historical writer. But he grew increasingly frustrated with his lack of success in that field and moved to the USA to take up song writing. It's well known that Cohen's songs were recorded by folk superstar Judy Collins before he himself got the chance to record them, but Suzanne - which scored her a hit - was sure evidence that Leonard certainly had what it took to be a gifted songwriter. With a low register, he sang his own songs without showiness, but deep emotion and quiet passion. His guitar playing began as rudimentary, but soon became skilful and subtly awe inspiring. His unique brand of song craft and delivery soon earned him a cult status, one that grew and grew over the subsequent decades. His records have appeared sporadically, but each one has been nothing short of a major event to his fan base.

This book explores those albums, looking at the music and interviewing those who were there, all without going into Leonard's personal life. There are a few Cohen books out there, some that don't sum up the sheer power of his music and seem more interested in the gossip. I chose to delve into those marvellous albums, from his early poet folkie days, through his keyboard driven era and to the modern day where he's the most mature globe-trotting, arena packing entertainer out there. It certainly is an amazing musical adventure.

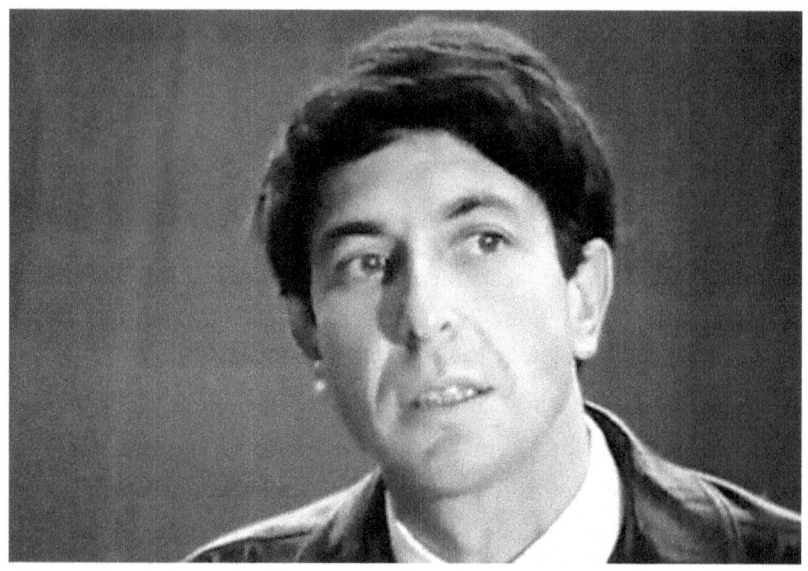

LEONARD COHEN'S EARLY YEARS

Leonard has been around for so long now - this romantic, poetic, enigmatic, legendary figure - that it seems almost strange to trace his origin back to a single time and place. After all, he's lived so many lives and been all over the world, yet Cohen began his life like many others. He was born on the 21st of September 1934, in Quebec, Canada. His family were Jewish and middle class, his father Nathan owning a sizeable clothing shop. The family had been affluent and influential in past generations too; for example, his mother Marsha was the daughter of Rabbi Solomon Klonitsky-Kline and Cohen's granddad was Lyon Cohen, the founding president of Canadian Jewish Congress. His childhood was similar to that of many young Jewish boys, except for the fact that his father died when Leonard was only 9. It was to have a profound effect on him (his first poetry book was dedicated to his father). When his father passed away, the young

Leonard went and retrieved his father's favourite bow tie. He wrote a note, placed it inside the tie and buried it in the back garden. Not only did Cohen recognise this as his first piece of writing, he also saw it as a symbolic moment. "I've been digging in the garden for years," Leonard said, years later. "Looking for it. Maybe that's all I'm doing, looking for the note."

At other points he has reflected upon the financial side of his family's life. "We weren't a lavish family," Cohen told the Evening Standard back in 1968, "but we must have been quite well off, and I grew up like the Queen believing it was unnecessary to concern myself with the making of money." Perhaps this explains why Cohen has never really been too concerned about record sales, or his own marketability for that matter.

In one interview, with Stina Lundberg in 2001, Leonard spoke more about his childhood. Well, he spoke about his dog, or more specifically its death. "He died when he was about 13 years old," Leonard said, "which is quite old for a dog. And he just asked to go out one night – you know how a dog will just go and stand beside the door? – so we opened the door, it was a winter night, and he walked out, and we never saw him again. And it was very distressing. I put ads in the newspaper, and people would say, Yes, we have found a Scottie, and you'd drive 50 miles and it wouldn't be your Scottie. And we only found him in the springtime when the snow melted, and the smell came from under the neighbour's porch. He'd just gone outside, and gone under the neighbour's porch to die. It was some kind of charity to his owners."

These events would essentially help carve out the adult Leonard Cohen, both as a man and an artist. Seeing as his early life was full of such powerful and dark events, it's little wonder that much of Cohen's poetry focuses on the darker aspects of life and the human soul.

Cohen went to Westmount High School and studied music and poetry. As a teenager, he played guitar in his own folk group. "When I was 17, I was in a country music group called the Buckskin Boys," Cohen told the Melody Maker in 1975. "Writing came later, after music. I put my guitar away for a few years, but I always made up songs. I never wanted my work to get too far away from music. Ezra Pound said something very interesting, 'When poetry strays too far from music, it atrophies. When music strays too far from the dance it atrophies.'"

Leonard spoke about his life long affection for both music and the spoken word, specifically together, in a 1984 interview. In many ways, this one comment can define what Cohen would go on to do in his music career; combine music and words in an elevated but unpretentious fashion. "I think that I was touched as a child by the music and the kind of charged speech that I heard in the synagogue, where everything was important," he said. "The absence of the casual has always attracted me. I've always considered the act of speaking in public to be very, very important. I always feel that the world was created through words, through speech in our tradition, and I've always seen the enormous light in charged speech, and that's what I've tried to get to. That's a hazardous position because you can get a kind of highfalutin' sound that doesn't really strike the ear very well, so it has its risks, that kind of attachment. But that is where I squarely stand."

Cohen spent evenings in Main Deli Steak House, watching the seedier aspects of life go about their rituals, the gangsters and the pimps, and drank coffee in Saint Joseph's Oratory. In this era, Leonard would pen a lot of his classic songs, or at least the lyrics for them, no doubt as a result of people watching in the rowdy locations.

Cohen studied at McGill University and first had his work published in 1954 in a poetry magazine. Two years later he released his first book of poetry, Let Us Compare Mythologies, still in his early twenties. Leonard has often said that he first got into poetry to win over the ladies, assuming that was what every young man did at the start of an infatuation. "I must have looked extremely absurd because I wrote all my poems to ladies thinking that was the way to approach them," Leonard said. "Anyway, for some reason or other, I put them all together in a book and I was suddenly taken seriously as a poet, when all I was really was a kind of stud – not a very successful one either, because the successful ones don't have to write poems to make girls."

Upon his graduation, Cohen wrote poetry while taking on casual jobs, and his next book, The Spice-Box of Earth, was published by McCelland and Stewart in 1961 to great acclaim. Due to an inheritance from his later father, Cohen was more able to explore his literary ambitions (or his needs) without fear of poverty, as is often the case when the middle classes get into the arts.

Cohen opted for an almost reclusive life style when he moved to the Greek Island Hydra. He bought the house there for $1500, and was apparently not nervous about moving abroad, which is rather odd, considering he needed a translator to close the deal in the first place. But Leonard soon found he loved the Greek way of life, the gatherings, the donkey rides, the sing alongs, and of course the women. It was here he met Marianne, the inspiration for some of his finest songs.

While there he wrote more poetry and also his seminal novels, The Favourite Game and Beautiful Losers. Both books earned him fame in Canada, as well as numerous awards. But it wasn't much to live on. A literary success in Canada was hardly something you could retire on, so Leonard's interests went elsewhere.

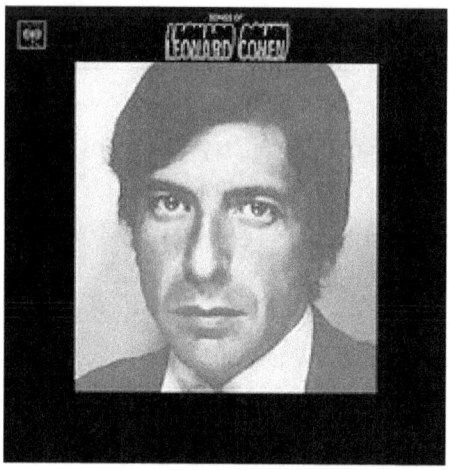

SONGS OF LEONARD COHEN (1968)

One of the most powerful, striking and perfectly executed debut albums in the history of music, Songs of Leonard Cohen has the feel of a crusty old poetry volume, being opened up at random points, read out with the accompaniment of only an acoustic guitar, and a few other exotic sounds fluttering around the mix so delicately. It's one of those albums where every song is just the right length, every line is a gift, each sentence thought provoking, all the notes finely placed and each sound destined to be where it is. This may sound over the top and pretentious - it probably is - but this is how Songs of Leonard Cohen makes me feel.

Cohen had tired a little of life as a writer on the primitive Greek Island of Hydra and was finding his interest taken more by the enigma of music. Not that Leonard was a stranger to the music world of course, just a distant acquaintance. By 1966, he was in his thirties (ancient in the 1960s pop world) and had last played in a band as a teenager. He hadn't quite kept his musical skills up to scratch.

Leonard once told a story about a mysterious man who gave him guitar lessons when he was young, and the tale ends in a suitably doomy fashion. It's exactly like the kind of thing you'd hear in a Leonard Cohen song, with a tragic conclusion so powerful that it sounds made up. But it isn't fictional, this was real and perhaps it inspired him on his path to put poetry to song. "There was a young man in the park behind my mother's house," he said. "A dark young man, very handsome, played flamenco guitar. I asked him if he would give me a few lessons. He did. He gave me three or four lessons. On the basis of those lessons I wrote most of my songs. He showed me some changes with the guitar that was very, very important to me. He didn't turn up for the final lesson, and I phoned his boarding house, they told he'd committed suicide. I don't know whether that was because of the progress with his student; or I think perhaps he had other issues."

By 1966, Cohen was interested in song writing and primarily had aims of being a country musician. Instead, on the way to Nashville, he stopped off and found himself in the same place Bob Dylan had made his name; New York. He showed his face, absorbed the various scenes and indulged himself in the booming city culture. He mixed with Andy Warhol and his entourage of Factory Superstars, taking in everything the Big Apple had to offer. It was a world away from Hydra.

Of course it didn't take long before people picked up on Cohen's song writing talent. Judy Collins recorded a beautiful version of Suzanne and not long afterwards, like they had with Dylan a few years earlier, everyone wanted to record a Leonard Cohen song. John Hammond, the same man at Columbia who had taken a chance on Bob Dylan, was another person to spot Cohen's individual genius and quickly signed him up.

Then there's the album itself. When the quiet hum of the microphone begins, we hear the opening acoustic notes to one of Leonard's signature songs, the magnificent Suzanne. His voice is crisp and up in the mix, the lyrics mysterious and guarded while also being clear and relatable. Suzanne is a woman Leonard had a friendship with; they drank tea together at her apartment and the song describes the potentially mundane activities in such fine a way to make them fascinating. But Suzanne can be taken on so many levels. A lot of people might see themselves in Leonard's shoes, a man gazing at someone he doesn't quite understand, a girl he will never be intimate with, but may consider what that might feel like.

How did the subject of Leonard's poetry feel about the song after hearing it? "Flattered somewhat," Suzanne Verdal, that old friend of Leonard's, told BBC Radio 4. "But I was depicted as I think, in sad terms too in a sense, and that's a little unfortunate. You know I don't think I was quite as sad as that, albeit maybe I was and he perceived that and I didn't. He was 'drinking me in' more than I even recognized, if you know what I mean. I took all that moment for granted. I just would speak and I would move and I would encourage and he would just kind of like sit back and grin while soaking it all up and I wouldn't always get feedback, but I felt his presence really being with me. We'd walk down the street for instance, and the click of our shoes, his boots and my shoes, would be like in synchronicity. It's hard to describe. We'd almost hear each other thinking. It was very unique, very, very unique."

The lyrics aside, it's also the music itself and the various sounds around the mix that freeze you to the moment. The sound of Leonard's voice, even without the rich lyrical touches, is hypnotic in its low drawling tone, and in the repetitive, addictive melody he is delivering. The guitar is deep and uncluttered, while the strings are

tastefully placed in the mix. A lot of productions from this time tended to lay on thick, lush strings which dominated the mix. But producer John Simon ensured they complimented Leonard's voice and lyrics rather than ruled over them. Underneath Leonard's mild tones are the backing vocals of Nancy Priddy, who adds subtle vulnerability to the track. There is an almost holy quality to Suzanne, as there is with Cohen's later Hallelujah, that reaches unprecedented levels without ever getting schmaltzy or "Walt Disney" with the music. A truly remarkable start to a remarkable recording career.

The dark sounds of Master Song follow, again with Cohen on acoustic, accompanied by bassist Willie Ruff. The odd spot of exotic Eastern instrumentation colours the song majestically, along with strums of an electric guitar. These sections were played by a band Leonard had seen in a club called Kaleidoscope (the US band, not the Pete Daltrey led British group), and throughout the record they inject some subtle mysticism into proceedings. Master Song has another dark, hypnotising melody, sung by Cohen in a restrained, strange manner, as if sung through the gritted teeth of a sinister grin. The whole feel of the song pulls you in and keeps you fixed in your chair; you are left catatonic, drifting into this weird, unsettling but simultaneously comforting place. These contradictions visit upon you again and again when listening to Cohen's music, the mix of muddled emotions; perhaps it's something only a fan of Cohen can understand. Nirvana icon Kurt Cobain once sang "I miss the comfort in being sad." There is a sad comfort to these songs. Perhaps it makes sense that Cobain mentioned Leonard in one of his final songs, Pennyroyal Tea.

Winter Lady is a brief, somewhat lighter venture down a similarly unknown road. But there is a calm joy evident in Leonard's tone, and an uplifting feel to the understated musical flourishes. Leonard knows this woman won't be staying too long, that he's just a station on her

way. He is one more stop on her journey, but he doesn't seem to mind all that much.

Perhaps one of the starkest and most hauntingly beautiful songs in the Cohen canon is The Stranger Song. Speaking very quietly, definitely not singing, Cohen recites a multi faceted poem that seems to float above you on so many levels. Musically it's bare, startlingly so, with only Cohen's monotone voice and impossibly speedy flamenco style guitar in there. The two elements - that fast acoustic work and his near dead voice - really shouldn't work so well together, but the truth is they blend so perfectly. You find yourself floating off on this eerie trip, forgetting what's going on around you.

One of the sweetest songs on the album is the wonderful Sisters of Mercy, another one of Cohen's descriptive but also arguably cryptic songs, full of exotic sounds (bells, acoustics, accordion, tribal drums), and a soothing atmosphere. Lyric dissectors and Cohen fanatics could inspect and decipher this song until the cows came home, but I find Leonard's own words on the song's genesis more telling, and actually very charming too. "I was in Edmonton during a snowstorm and I took refuge in an office lobby. There were two young backpackers there, Barbara and Lorraine, and they had nowhere to go. I asked them back to my hotel room, they immediately got into the bed and crashed while I sat in the armchair watching them sleep. I knew they had

given me something and by the time they woke up I'd finished the song and I played it to them."

There's genuine affection for the two young ladies in this song, the kind of warmth that would not be so evident and shine out of the recording so brightly had it just been an empty erotic encounter of some sort (like the coldness of the later Chelsea Hotel for example). This is one of Cohen's most pleasant and straight forward tributes in my view. "It doesn't matter if I don't mention their names," he said before one live rendition of the song. "They visit me with humiliation every time I play this song."

The energy is up for the magnificent So Long Marianne, something of a Leonard Cohen sing along these days that everyone seems to love. The drums drive the rhythm, above which are Cohen's sturdy acoustic strums, the rolling bass and the wonderful female backing vocals. The song concerns Marianne Jensen, who Cohen first knew when he was living on Hydra, the Greek island, back in 1960. They lived together in various parts of the world and she inspired some of Cohen's finest poetry, as well as this anthemic classic.

"I saw her and her husband walking arm in arm," Cohen recalled of the first time he saw Marianne, the song's heroine. "I was very lonely and said to myself how lucky they are, that they have one another. I had no idea I would spend the next decade with this man's wife. He was a fine Norwegian writer and he left. Somehow Marianne came into my arms."

It's the kind of song that any real songwriter would be proud to call their creation and it quickly put Cohen in the same league as Bob Dylan, due to the combination of vivid poetry, a hooky chorus and tasteful musical accompaniment. There's a feeling of sadness in the voice, but also a majestic lust for life, a celebration that he and Marianne met in the first place, when they were "almost young."

It slows down once again for the gorgeous Hey That's No Way to Say Goodbye, boasting another one of Leonard's simple plucking acoustic guitar lines and a calm, appealing vocal. Again, the backing by Nancy Priddy adds the warmth of a woman to the arrangement and there are plush guitars, a hopping bass line and just a hint of more out-there instrumentation on the chorus.

There's a black waltz in the form of Stories of the Street, with an emotional Cohen vocal and solid acoustic strums, plucking guitars and a thumping bass line. I really love the minor key changes, the apocalyptic feel and the cavernous but still light echo in Cohen's voice. It's one of the most unsettling tracks on the record, and the same goes for the next number, the Latin flavoured beauty of Teachers. Again, Cohen's vocal melody is repetitive and slightly fevered, recounting various meetings with colourful characters. The frantic acoustic pairs itself wonderfully with the Spanish notes on the other side of the mix. Throughout the relentless drive of the music, Leonard still demands our attention with carefully recited words, so we hang on his every single word, with each syllable that leaves his mouth being a life lesson.

He saves the oddest and most peculiar song til last, the brilliant One of Us Cannot Be Wrong. It features a heavy, melancholic vocal, simplistic acoustics and quietly humorous but also darkly surreal lyrics. After Cohen delivers his captivating account, he starts to wail like a lost soul, nothing more than a destroyed shell of a man, and as the track fades out we hear his final howls of torment. His cry is accompanied by a slightly off tune whistle, adding to the sense of derailed turmoil. A strange way to end the album, but also a fitting one. His tortured voice echoes on and on in your head long after the record is over.

Songs of Leonard Cohen was recorded in August of 67 and put out over the new year period. It was a slow burner, but Leonard's brand of folk poetry seemed to be more accepted in the UK and across Europe than it was in the US, where it took over twenty years to go gold. It did best of all in Britain, where all kinds of folk music was dominating the charts in the form of sub genres like acid folk (Incredible String Band for example). Cohen's highly original approach appealed to the students, the music aficionados and literature buffs. It was music for the thinker, the ponderer, the one who chose to listen rather than just dance to the beat. Anyone else in that year of 1968, an era of psychedelic freak outs, would have missed the point. There was nothing to boogie to. This was an introverted record, for the introverted moments in your life.

Meanwhile, some critics in the US didn't really get it. Rolling Stone were critical, writing "It is a strange voice - he hits every note, but between each note he recedes to an atonal place - his songs are thus given a sorely needed additional rhythm. The record as a whole is another matter - I don't think I could ever tolerate all of it. There are three brilliant songs, one good one, three qualified bummers, and three are the flaming shits." Of course, Suzanne, Master Song and The Stranger Song are the ones they picked out as the true gold, while the more challenging and avant-garde songs infuriated them.

This album has now entered the canon of classic records, and it's had a long lifespan, even if it did take years for it to enter the wider public's psyche. It's an album that gets by on the most simple of musical ideas, with extraordinary lyrics and an atmosphere very much of its own to enhance its bare, skeletal frame. Even in Cohen's discography, an admittedly wonderful place, it sits isolated in its own little space. A masterpiece that cannot be explained, and something of an enigma even to its creator I am sure.

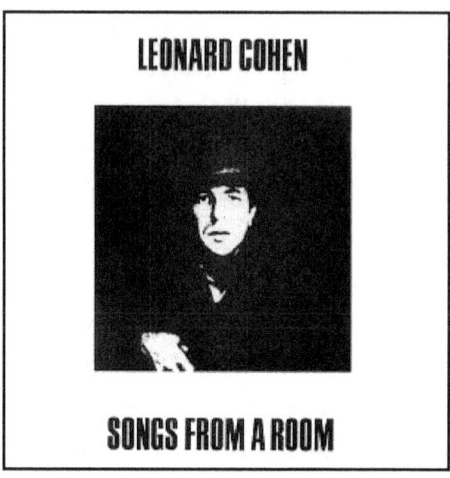

SONGS FROM A ROOM (1969)

By 1969, Cohen was a famous man in the UK, not to mention a serious, and very unlikely pop star. Well, to a point at least. His albums were top ten sellers that's for sure, but you weren't about to see him on Top of the Pops miming to Bird on the Wire. His second album, Songs From A Room, proved to be even more successful than his debut, yet there was a darker feel to some of the music and indeed the lyrical content. Recording had started in 1968 over in Hollywood, with David Crosby in the producer's chair. It never really came off the ground, so Cohen ended up cutting it in Nashville, his original target destination when first coming over to become a song writer. He worked with the great Bob Johnston as producer, the man who had recently worked with Dylan on such legendary albums as Blonde On Blonde, Highway 62 Revisited and John Wesley Harding. It proved to be a magical pairing of minds.

There were to be no colourful flourishes on Songs From A Room, as there had been on the previous record, and the music proved to have an even barer quality to it. Rudimentary acoustic guitar was the most

predominant musical sound, but there were added bass, electric guitar and violin parts courtesy of Bubba Fowler, Charlie Daniels and Ron Cornelius. Still, this was Leonard's show and much of the attention focused on his lyrics, the gaps in sound making way for raw emotional power. His words are above the music at all times, floating ghostly atop the simple arrangements. "It's very stark," Cohen told Mojo in 2001. "A lot of my friends who were musical purists had castigated me for the lushness and over-production of my first record and I was determined to do a very simple album."

And simple it was. Starting with the blunt Bird on the Wire, it's clear that Cohen has gone even further inward, consulting his poetic tendencies even more precisely than on Songs of Leonard Cohen. Matching the no frills album cover (and its similarly ragged back cover showing Marianne herself at a table) this is immediately a record that makes no allusions to being fruitful, glamorous or "produced" in any way. Whereas his voice had sounded monotone and at times atonal on the first record, here it sounds beat, down and out, devoid of life, yet so human and real that it still moves you despite the lack of positive emotion. The tasteful string accompaniment and surreal Jew's harp make this a most unlikely combination of sounds and moods. From the pen of another, this really could have been a fairly standard, almost cinematic, somber cowboy romance. From Cohen, it's a doomed, almost apocalyptic ballad.

The song which Cohen often claims returns him to his duties first formulated when he was living on the Greek Island. Gazing from his window, he had spotted a bird on a telephone wire.

"It was begun in Greece because there were no wires on the island where I was living to a certain moment," he told Paul Zollo. "There were no telephone wires. There were no telephones. There was no electricity. So at a certain point they put in these telephone poles, and

you wouldn't notice them now, but when they first went up, it was about all I did - stare out the window at these telephone wires and think how civilization had caught up with me and I wasn't going to be able to escape after all. I wasn't going to be able to live this 11th-century life that I thought I had found for myself. So that was the

beginning. Then, of course, I noticed that birds came to the wires and that was how that song began. 'Like a drunk in a midnight choir,' that's also set on the island. Where drinkers, me included, would come up the stairs. There was great tolerance among the people for that because it could be in the middle of the night. You'd see three guys with their arms around each other, stumbling up the stairs and singing these impeccable thirds. So that image came from the island: 'Like a drunk in a midnight choir.'"

It's a very sad song, reflecting the lost boredom of gazing, not even dreaming, and Leonard really does sound like he's a man about to give up on life. But yet, it's still so beautiful and pure. Whereas Cohen himself had called Bird on the Wire a straightforward country song, Story of Isaac is one of his more complex and multi layered ones. It's a protest song which Leonard said he was adamant to force beyond the basic anti-war sentiment, perhaps in a bid to avoid any backlashes and getting himself too tied up in the horrific Vietnam war. Dylan, for all his early protest songs, which clearly are political in their subject matter, was never a political animal (politically naive is how fellow songwriters of the early 60s folk movement called him) and stayed clear of the war in Vietnam. Cohen as a songwriter can present us with

a song, but surely it must be up to us what it's about, depending on the person and how they interpret the words. Cohen sings about people, people in different situations, not the situation itself; keeping the human element to the fore of the problem.

"I was careful in that song to try and put it beyond the pure," he told John McKenna, adding "beyond the simple, anti-war protest, that it also is. Because it says at the end there the man of war the man of peace, the peacock spreads his deadly fan. In other words it isn't necessarily for war that we're willing to sacrifice each other. We'll get some idea - some magnificent idea - that we're willing to sacrifice each other for; it doesn't necessarily have to involve an opponent or an ideology, but human beings being what they are we're always going to set up people to die for some absurd situation that we define as important."

A Bunch of Lonesome Heroes continues the thread of eerie otherworldly ballads that lead the way through Songs From a Room. Even though the chords, pace and acoustics are similar to So Long Marianne, the instrumentation pulls it apart from its earlier counterpart. Leonard's vocal is similarly full of both hope and defeat, as the Jew's harps boing around the mix and the keyboards/electric guitars add a strange space cowboy feel to the track.

The Partisan is a very powerful moment, delivered in typically laid back style by Cohen, even though he is delivering an old song about a weighty subject. It's about the French Resistance during World war 2, originally penned by Emmanuel d'Astier de la Vigerie and Anna Murly. Hy Zaret adapted it into English, but Cohen keeps it in both English and French, staying true to the spirit of the subject. The bass pumps like a slowing heart beat, Cohen plucks with three fingers, the backing vocals soar so heavenly and Leonard utters the words as if they were completely his own. Stunning.

Seems So Long Ago Nancy is one of his saddest tracks, with a heavy melody and downbeat mood. The acoustic and bass interplay with one another calmly, with an under current of doom and depression making it one of his gloomiest moments. Then again, it is about someone he knew who shot herself, taking her life because she felt so alone. Play this to a newcomer and they'd likely shriek in horror, following the cliché of Leonard Cohen the great messenger of dread.

There are a series of songs that bring to mind old western movies next, like The Old Revolution, an acoustic waltz again punctuated by Jew's harp. The Butcher is an understated dirge with dull acoustics and a no frills execution of Leonard's meeting with a butcher slaughtering a lamb. Possibly the finest song on the record, although it shares a lot of musical elements and general mood with the other tracks, is the excellent You Know Who I Am, which could have easily fit on his debut album comfortably.

As a whole, Songs From A Room is certainly more downbeat than Songs of Leonard Cohen, but it's definitely not his darkest record (that goes to his next album, Songs of Love and Hate). The fact it was a Number 2 hit in the UK upon release seems ludicrous today and nothing as introspective and off beat would ever get into the top 40 these days.

"Well, it looks like Leonard Cohen's second try won't have them dancing in the streets either," wrote Rolling stone in a rather daft review at the time. "It doesn't take a great deal of listening to realise that Cohen can't sing, period. And yet, the record grows on you, and if you give it a chance, it has something to offer. But you can hardly be blamed if you aren't willing to take the time. The first thing that has to be withstood is his voice. It's monotonous in a literal sense of the word. He seems to be sort of dragging one tone slightly up and down the chromatic scale. His voice almost never has an edge to it; it just

remains where it is. Probably this is just as well. He knows his limits. Just why he wants us to know them is another question. In our cases, it presents a formidable barrier to the understanding of his poetry, rather than being an unobstructive vehicle for it. The predominant mood is one of nostalgia and a rather wistful tenderness. And to someone who can relate to this sort of mood, the album would be appreciated. But, if you're looking for more than a portrait of moody Leonard Cohen, and in search of more substantial music, then pass this by."

Clearly Rolling Stone handed the review over to someone who was never going to get Leonard's style of music. The rather narrow minded perception of Leonard Cohen at this point in time is where the clichés and misconceptions began. They got bogged down with the minor keys, the monotonous voice and grim lyrics, but didn't step back and look at things from a wider scale. Firstly, these are stories, poems, words to take in and allow to wash over you, even if you don't know what the song in question is fully about. Besides, it doesn't matter if you do or do not know what all the lyrics mean anyway; it's more about the beauty of words and the way Cohen chooses and presents them to us like gifts. And I see the musical accompaniments like subtle colours in a painting. They prop up the themes and the intentions, never intruding or becoming showy in the slightest bit. This is all good and OK in other music, but with Leonard's songs, especially those lacking in proper rhythm or drums, it's something of a no-no to flex ones musical muscles. These are snapshots, brief tales, observations if you like, and no one does them like Cohen. I admit, I first found Songs From A Room to be really a bit too heavy, but it grows and grows on you, as with much of his finest work. A challenging nut well worth cracking open.

24

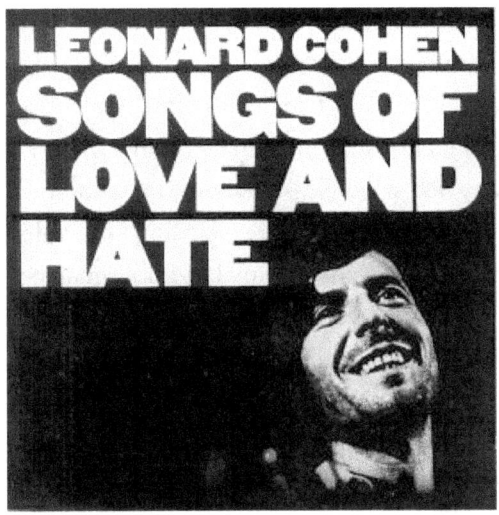

SONGS OF LOVE AND HATE (1971)

Leonard Cohen redefines what it means to have the blues on 1971's Songs of Love and Hate, the last of his later 60s, early 70s trilogy of folk poetry records and definitely his most weighty, obtrusive and challenging album to date. Considering those three words describe this album perfectly, it's something of a miracle that you can get any enjoyment out of this album at all, let alone time and time again.

Bob Johnston, who had worked his magic on Cohen's last album, Songs From A Room, was back on board for production once again. After a successful performance at the Isle of Wight Festival the year earlier, Cohen was riding on a creative wave by the time Songs of Love and Hate arrived. Ron Cornelius, a man who was now acting as band leader of Cohen's group, dubbed The Army in concert, was also still around to add varying shades of light. It was recorded in Nashville in September 1970, with one track recorded at the afore mentioned Isle

of Wight Festival (Sing Another Song, Boys) and some sessions done at the world famous Trident Studios in London.

It begins with one of Leonard's most troubled songs, Avalanche, which is almost frightening in its quiet intensity. The frantic acoustics and rising strings make way for a soulless, hollow, but strangely compelling vocal from Leonard. The lyrics are startling, his voice ludicrously deep, while again the music is minimal but still manages to be extremely intrusive. It's as if it acts as a warning of something bad about to happen. Most unsettling.

Many people, when approaching Cohen's work, focus solely on the lyrics, the poetry and their meanings. We can all look into the words and pull out our own meanings, but most of the time these are mere theories that never reach a conclusion. Only the writer knows the true meaning of course. For me, Leonard's work is about the whole picture; the beauty or grotesque nature of the words, the way in which he sings or recites them and the music that backs them up. We could go on about interpretations (Avalanche in particular is a complex song, describing a man who has lost his soul, a hunchback who feels nothing anymore), but for me Cohen's songs are about so much more than hidden meanings or the literal motives. They are naked expressions in their own form and the way they are musically dressed has just as much to do with the conclusion as the words.

Last Year's Man is not quite as full of dread, and its down beat feel is much less suffocating than on the shattering Avalanche. The third track is Dress Rehearsal Rag, an excellent Cohen monologue which he never attempts to make tuneful. The vocal is impassioned, the lyrics unflinchingly dark; he yells, hollers, and sounds as if he's in pain at times, as the strings deeply rise beneath his tired voice.

Diamonds in the Mine is musically more upbeat, but Cohen's voice is more raw and atonal than ever. The lyrics are fantastic though and

don't really ask for a melody. Cohen's ripped, angry recital is backed up by fine female backing vocals by Corlynn Hanney and Susan Mussmano. These are some of my personal favourite Cohen lyrics; they are bleak, telling us there's nothing left, no chocolates, no diamonds, no letters, no hope... nothing. Cohen becomes increasingly full of rage, his knackered voice tearing as he reaches the end. The funny thing is that the music sounds like standard county fare, with its bouncing bass and electric guitar noodling. When you stick Cohen's tortured, unpleasant but ultimately compelling vocal over the top it gels surprisingly well, even though it really shouldn't. Another contradiction that can't quite be pin pointed.

Possibly the finest song on the album, in more ways than one, is Famous Blue Raincoat, which fits nicely with the sombre ballads at either side of it. Musically it is bare, while the female backing vocals help ease the pain in Cohen's voice, which occasionally goes painfully out of tune. Still, there is a beauty of honesty to it that makes you celebrate the sonic flaws rather than criticise them. Any song that signs off with a laid back "sincerely L Cohen" has got to be a winner (the same with Diamonds in the Mine, which he ends with a casual "that's all I got to say."). This song had been around for a while before it was recorded for this LP and there is what I feel to be a far superior rendition of it on a BBC concert bootleg from the late 60s.

Famous Blue Raincoat, despite authors and experts with their many speculations, seems to be autobiographical. "I had a good raincoat then, a Burberry I got in London in 1959," Cohen once said. "It hung more heroically when I took out the lining, and achieved glory when the frayed sleeves were repaired with a little leather. Things were clear. I knew how to dress in those days. It was stolen from Marianne's loft in New York sometime during the early seventies. I wasn't wearing it very much toward the end."

One of his most acclaimed and dissected songs is the daring and powerful Joan of Arc. Basically a conversation between Joan and the fire which burns her body at her execution, it's a sad song and not one that a newcomer should visit if they are hoping to hear more than Cohen the troubadour of troubles. "I was thinking more of this sense of a destiny that human beings have and how they meet and marry their destiny," Cohen said of his masterpiece. "I don't want to suggest in that song that what she really wanted was to be was a housewife. What I mean to say is that as lonely and as solitudinous as she was she had to meet and be embraced by her destiny; seen from the point of view of the woman's movement she really does stand for something stunningly original and courageous."

Songs of Love and Hate was another solid seller, but it was an album that concreted the legend of Leonard being the master of melancholia, or the Don of Doom. It was also an album he immediately seemed to dislike. "I suppose you could call it gimmicky if you were feeling uncharitable towards me," he said after its release. "I have certainly felt uncharitable towards me from time to time over that record, and regretted many things. It was over-produced and over elaborated... an experiment that failed."

Some reviews would only agree with Leonard's summary of Songs of Love and Hate. While it's something of a classic in the Cohen canon these days, it was met with venom upon release. "But this record, alas, goes back to all the trash that cluttered up the first album," spat Rolling Stone, one of the leading music publications who unfortunately always seemed to give Leonard a hard time. "Schlock horns, schlock strings, schlock chorus - as if to make of it a style. Recognizable, yes. No one but Leonard Cohen could have come out with these arrangements; but a style, no. There are a couple of terrific songs on this one, though the record as a whole has not the charm

that his first develops after a long while. It is not as likable, because it is frequently downright depressing."

BBC Music weren't wrong when they called it a scary album (one of the scariest of the last forty years in fact), but there is a strange comfort to be had even in Leonard's darkest work. His voice becomes familiar, like an old friend visiting upon you to give you a little downbeat wisdom before leaving again much too soon. There may at this point be something of a formula in place, as the album's pacing, song style and lyricism shares a lot with Songs From A Room, although less so with the more bright (at least in comparison) debut record. And as far as what people expected of Leonard Cohen, Songs of Love and Hate reinforced their view of him as the most depressing man in modern music.

After the release of the album, Cohen seemed to go through a black period, especially in regards to his music and the business surrounding it. Clearly he was a man who felt under pressure by a major label who sold him like a piece of product, and did not see him as an artist. "I'm no longer a free man," he told the NME in 1973. "I'm an exploited man. Once, long ago, my songs were not sold; they found their way to people anyway. Then people saw that profit could be made from them; then the profit interested me also. I have to fight too many people on too many levels to have to fight about money as well."

"I don't want to cut out completely," Cohen told the Melody Maker about his planned exit from music. "I want to continue writing songs, but I want to return to another rhythm; a rhythm I'm more used to. No matter how withdrawn you feel from the scene – no matter how little you think you're really involved with it, you find yourself drawn into it. You find yourself worrying like 'I should have another song.' Well... forget it. I just feel like I want to shut-up. Just shut-up."

And shut up he did, for a short while at least.

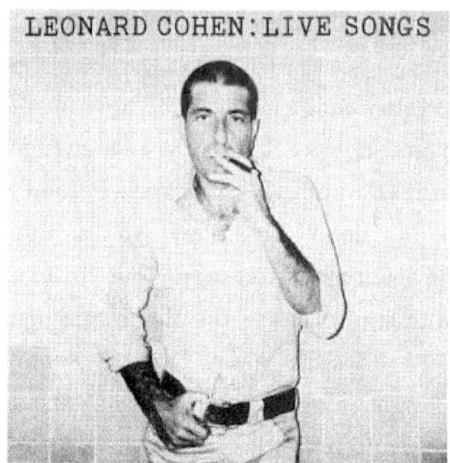

LIVE SONGS (1973)

Leonard Cohen's first live document came out in 1973, between two of his strongest studio albums. Live Songs was taken from recordings made in Europe and beyond in 1970 and 1972. In fact, even though he had played live before at various times, 1970 was the first year that Cohen could be convinced to go on a tour. He went to Europe firstly, obviously feeling safer in the place where his popularity was wider and his individual style was readily accepted.

Cohen had asked his producer Bob Johnston to assemble a decent live outfit for him, and somehow was convinced by Leonard that he himself would make the best piano player. To his own surprise, Johnston accepted the job. "I said, 'I'll get you the best goddamn band that ever walked on stage,'" recalled Johnston to Uncut. "He said, 'I just want your friends.' So I got Charlie Daniels and people like that and we smeared every place in glory. They can wheel Leonard out when he's 180 and he'll still do the same thing."

Live Songs captures this golden era of 1972 (with snatches of 1970 too of course) wonderfully, although not quite as wonderfully as Tony

Palmer did in his extraordinary 1974 documentary Bird on a Wire. The album cover also captured Cohen's pissed off state of mind at the time, and it certainly would be an uninviting advert for anyone not already familiar with his work. But when I first saw it, it only got me more interested in its contents.

Comparing to the more celebrated live albums of the day, Live Songs is very low key and certainly not the clichéd extravagant concert LP you got from other artists. On the gorgeous opening Monologue, we get a hint of what is to come; private insights into Cohen and his Army on stage. The music is played with class and restraint, so let's be clear, this is no Frampton Comes Alive or Song Remains the Same... it's much better of course.

Passing Through is a gem, with its country tinged angle and sing along vibe. There are darker, more eerie moments too that must have been startling to witness in the flesh. The version of You Know Who I Am has the atmosphere you could cut with a knife; fine Spanish style flourishes and a low Leonard vocal. The Paris recording of Bird on the Wire is spellbinding, a massive improvement on the studio version on Songs From A Room, with it harbouring much more showmanship, drama and musical beauty.

There are more unusual moments here too, like the roaming quality of Improvisation and a mammoth 13 minute version of Please Don't Pass Me By. The latter is preceded by a monologue, where Cohen recounts seeing cripples and handicapped people, whom he felt could easily join together and sing the rambling song which follows. Queen Victoria is one of his doomiest songs, reflected perhaps in Cohen's words to Melody Maker when he said "Live Songs represented a very confused and directionless time. The thing I like about it is that it documents this phrase very clearly." No kidding.

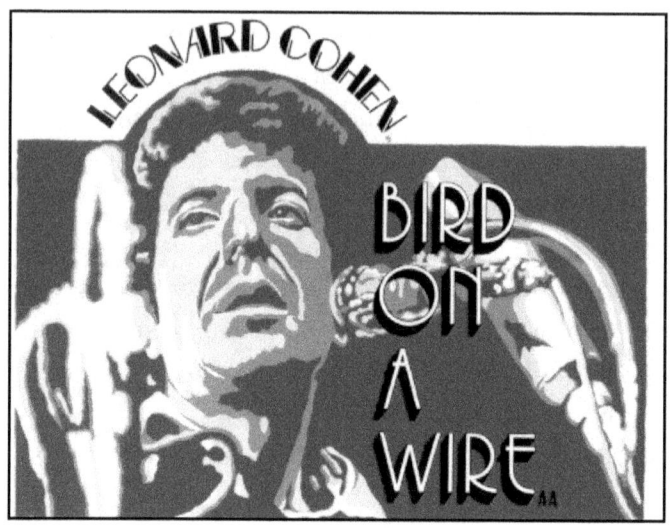

TONY PALMER INTERVIEW

Tony Palmer is an acclaimed filmmaker who shot Bird On A Wire, a document of Cohen's 1972 tour. He sent me a lengthy history of the film process and allowed me to ask him a few retrospective questions about his views on the film and its making.

"My film about Leonard Cohen's 1972 European Tour has a complicated history. Let me clear up one or two complete misconceptions, I might want to say misrepresentations. I was asked to make the film by Marty Machat, Cohen's long-time manager right up until his death in 1988. It was essentially his initiative, at least in part because he feared Leonard might never tour again thereafter. Mercifully this did not turn out to be the case, but given that at the time Cohen had frequently asserted: a) he did not enjoy touring, saying it exhausted him for no good purpose; b) he hated having to repeat the same old songs night after night, claiming he was rendering

them meaningless by endless repetition; c) he believed he was a poor performer on stage, crippled by an indifferent voice; and d) as his first three albums had sold indifferently, he thought he might not have an audience. All of this he explained to me the first time we met, in Machat's office in New York, October 1971. He was resigned to a film being made about the tour, however, because he hoped this might just bring him to a wider audience. I say 'resigned' because he was less than enthusiastic, especially when I said a condition of my becoming involved was that I would require total access to whatever I thought was necessary for a stimulating, and I hoped positive, film. Very reluctantly he agreed, and Machat said he would pay for the film himself so that Leonard would not be burdened with the expense.

Leonard kept his word, and I was given complete access and encouraged to interpret the material collected in any way I thought desirable. I also said it would be pointless recording all of the songs for every single concert, so we agreed that although I would be there for all 20 concerts, I would only record the music on four or five occasions to be agreed. And as I felt very strongly that his poetry was a key to understanding the man, I also suggested that we film him reading some of the poems. With this he readily agreed. Indeed, so pleased was he with this idea that he even composed a poem especially for me, and wrote it out by hand and signed it in the frontispiece of my copy of The Energy of Slaves. And maybe what is valuable about the film today is not only that it contains 17 of his greatest songs performed by him in his prime (and it's nonsense - of him - to say he has no voice), but it has a real feel for the rough and tumble and difficulties of life on the road. I know of few other films where the backstage confusion comes so vividly to life, with Cohen apparently taking no notice whatsoever of the camera. And don't forget, this film was shot in 1972, with slow celluloid colour stock,

requiring a lot of light to get any decent exposure at all. With today's digital technology, we would have been virtually invisible. But I doubt if today we would be allowed such access.

With a budget of around $35,000, and a crew of only four, the filming schedule went ahead as planned and, as I am my own editor, the rough-cut of the film was delivered about a month after the tour finished. I've read that during the filming, according to Bob Johnston, many of the sound tapes were lost. Sorry, Bob; that's nonsense. The BBC asked to see the rough-cut and bought the film on the spot. Machat would have recouped three-quarters of his investment in one go. Alas, Cohen told me he thought the film was "too confrontational," and worried that he often appeared "exhausted, even wasted." While the latter is undoubtedly true, about the former I believed he was wrong.

However, my regard for him as a poet, a performer and as a man had grown hugely during the film, so I wanted to give him the benefit of the doubt. Machat asked me to make available all the raw material (the 'rushes' or 'dailies'), and "they would see what they could do." What I did not know at the time was that my assistant editor had told them he could do a whole lot better than me. Nine months later, and hundreds of thousands of dollars later (now of Cohen's money), a second version of the film was ready. I was told it was shown to the BBC, who turned it down flat saying "it was a mess." I now have a copy of their letter.

I was also told by Machat that he had refused to pay for the re-editing, thinking that this was now Cohen's responsibility. Version 2 had a brief theatrical outing and was shown for one night only at the Rainbow Theatre in north London, July 5^{th} 1974, almost two years after I had delivered the original version. I was not invited to see the revised version, was not at the Rainbow, and only saw it for the first time

recently. Had I seen it then, I would have insisted my name be removed, because although it contains about 50% of my original film, the structure has been destroyed, the musical editing is crass beyond belief, and the whole purpose of the film (which I shall come to in a moment) had been lost. When I read that Cohen would only promote the film "through gritted teeth", I think I can understand why.

As is well known, the film then apparently disappeared. Stupidly I had never kept a copy of the original version for myself. Meanwhile, in every biography of Cohen that appeared I read totally misleading information about the film – and incidentally, not a single one of these biographers ever bothered to consult me. I read that I had made a film about Tom Jones, which is why I was 'chosen'. I have never even met Tom Jones. I read that the film was Bob Johnston's idea. Simply untrue. One recent biographer even gets the title of the film wrong and also the date of its filming. And so on, and so on. Then, in late 2009, 294 rolls of film were discovered in a warehouse in Hollywood, many in rusted up cans that sometimes had to be hammered open, and returned to their present owner, Machat's son Steve, via shenanigans so tortuous they read like a B-movie plot. These cans were then shipped to me by, of all people, Frank Zappa's manager. I believed at first that nothing could be salvaged. The cans did not contain the negative (still lost); some of the prints were in black and white; and much of it had been cut to pieces and/or scratched beyond use. But when I finally opened one box and found most of the original sound dubbing tracks, I knew we had a hope of putting the jigsaw back together. So now, taking full advantage of the latest digital technology, this is what we have done, piece by piece, slowly and painstakingly, putting together almost 3,000 fragments. It took months and months, and probably cost more than the original

filming, and although it's by no means perfect, it's very close now to the original.

On balance, it doesn't look too bad, but it does sound wonderful – I would want to say that many of the recordings are far superior, certainly more moving, than their equivalent on disc. Above all, on balance what we have done is very close to the spirit of the original. Which brings me finally to the original purpose – my original purpose – in making the film. Yes, the songs are haunting, unforgettably so. The poetry, now restored having been deleted in Version 2 by persons unknown, is extraordinary. But so is the man. Cohen objected in the original film to scenes of a riot in Tel Aviv. I wanted the scenes because they showed Cohen's power over an audience, not by him shouting, but simply by his presence. Authority doesn't really describe it; transparent goodness is probably closer. And a profound belief that it is the poet's responsibility to address the problems of the world, the political problems. In this he is a true blood brother of Bob Dylan. Yes, his songs - like those of Dylan - are riddled with personal details, but like all great art they transcend these and make them relevant in a more universal sense. Just look at the lyrics for The Story of Isaac. They begin with references to a father appearing "when I was 9 years old." Cohen's father died when he was only 9. But that's not what the poem or the song is about. It is about those "who would sacrifice one generation on behalf of another" as Cohen says in the film. That belief, tough and uncompromising though it is, is the centre of my film, so woefully laid to waste by those who attempted to destroy what we had done. Now, my admiration for Cohen as a poet, a singer and as a man, remains undiminished. The original film was made with love, and I hope that quality once again shines through the restored film."

Here are my retrospective questions for Tony;

What do you think of that film now watching it back from 2016?

Very proud. When it won the Grierson Award for Best Documentary (2011) and the Gold Medal at the New York Film & TV Festival (2012), I felt fully justified in seizing back what in the end was my film.

Is there anything that bothers you about the edit now?

Structurally, no. It was just a pity that we never found the original negative, but given its recent success, maybe that wasn't so important.

Have you seen Leonard since and what have his comments been on it?

Yes. He sent a message which said that he was pleased that "the problem had now been resolved."

Of all the subjects you've had for your films, such a varied amount, how did Leonard differ as a subject to film and capture?

He didn't, actually. He's a remarkable man, a great performer, a song writer of genius, and most importantly a poet of considerable power. I was lucky to have had such access; it wouldn't happen today. But it was no different to the access I had to Margot Fonteyn, Britten, Walton, Callas etc. and I view him in the same way that I viewed them.

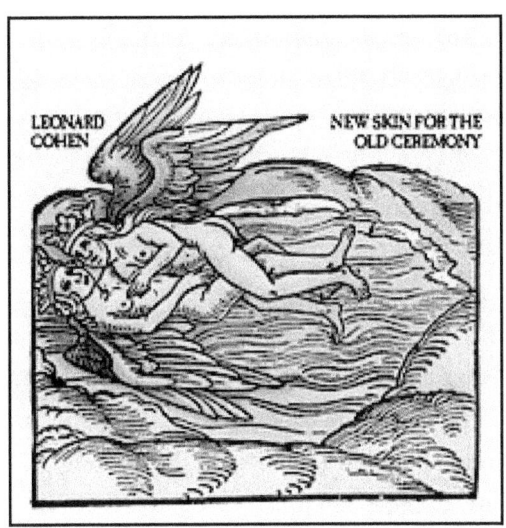

NEW SKIN FOR THE OLD CEREMONY (1974)

By 1974 Leonard Cohen was becoming less of a commercial concern, and although this may have had an impact on his life at the time, it really has no meaning to a fan looking back retrospectively on his work. If it was a darker time at all than the Songs From A Room era, it wasn't evident in the music. Most importantly, his commercial slide had no effect or reflection on the quality of his music. If anything, New Skin for the Old Ceremony is up there with Songs of Leonard Cohen and is a breath of fresh air when compared to the two records that came before it. Despite other problems, he always maintained a disciplined work ethic.

There is of course a very clear reason why this album is so much more enjoyable and varied as a piece of art. Bob Johnston was off doing other work and Leonard decided to share production with a new face to his crowd, arranger and producer John Lissauer. Although the arrangements were still quite sparse and much of the attention

remained on Cohen's voice and words, there were definitely more varied sounds added to the palette. It all amounts to one of the most satisfying, balanced and enjoyable albums of Leonard's career.

Leonard was happy with the record and didn't mind saying so. "I must say I'm pleased with the album," Cohen told the Melody Maker the year after its release. "It's good. I'm not ashamed of it and am ready to stand by it. Rather than think of it as a masterpiece, I prefer to look at it as a little gem. The original cover was a 16th century picture from an alchemical text depicting two angels in an embrace. Columbia felt unclothed angels were too much for the American public. A quarter of a million copies have been sold in Europe with this cover and there was not a single reference made to it. Since I designed it, I finally won the battle with Columbia, and they are reinstating the old album cover with a modesty jacket. With the exception of these minor problems, I've been very happy with the album and my present tour. I am surprised though to see so many young faces in the audience. Maybe it's a sign of a growing awareness, and I'm pleased, to say the least, that these individuals are taking an interest in my work."

"On this, his fifth LP," wrote the British Columbia University paper. "Cohen is once again hoarse and miserable. But the style has changed considerably after his last disappointing Live Songs album. If the lyrical style edges off into a darker, lonelier view of the human condition than even his classic downer album Songs From a Room achieved, so equally the arrangement of the music has changed... a classic album."

Rolling Stone didn't see it as such a classic though, although they blamed Lissauer's production. "Cohen's fifth album, New Skin for the Old Ceremony, is not one of his best, but there are songs on it which will not easily be forgotten by his admirers. The current album is

unfortunately marred by John Lissauer's coproduction and generally insensitive, melodramatic, obtrusive arrangements. Lissauer's sense of the ironic (banjos, tubas, congas, mocking brass) is as false as Cohen's is true." They concluded though with the kind of allusion Cohen himself might have been pleased with. "The Russian poet Joseph Brodsky has written: 'Alas, unless a man can manage to eclipse the world, he's left to twirl a gap-toothed dial in some phone booth, as one might spin a Ouija board, until a phantom answers, echoing the last wails of a buzzer in the night.' Leonard Cohen may be that phantom."

If anything I feel that the varied and exotic instruments only add charm and appeal to Cohen's song writing. On the opening song Is This What You Wanted, there are some marvellous lyrics no doubt, but the song is most interesting for its musical colouring; the violin, those heavenly female backing vocals and believe it or not, the groovy drums. The chorus is fantastic too and it's great to hear, for the first time in his discography, Leonard's voice against a proper rhythm.

Chelsea Hotel #2 is a stand out Cohen classic, a beautiful and simple acoustic piece with seedy, sad lyrics about his sexual encounter with

Janis Joplin at the infamous New York hotel. What makes this son so unusual and innovative is that, although it concerns a sexual encounter as the limousines wait outside, it is not celebratory at all and lacks the usual "another notch on the bed post" element as in other popular songs. They are an isolated pair, outsiders of beauty. When Cohen claims Joplin told him she preferred handsome men but would make an exception for him, this is clearly no boasting tale of rock excess. It's sung with sorrow and a knowing; what they were both after was empty and their encounter meant very little in the scheme of things. Cohen later expressed disappointment in himself at having outed Joplin as the mystery lover. "If there is some way of apologising to the ghost, I want to apologise now for having committed that indiscretion."

Lover Lover Lover is one of my personal favourite Leonard Cohen songs. It has a verse with Leonard in higher tone than usual, but still he's in turmoil and shame. In the chorus he is backed by the female singers, urging for this lover to return to him. It's a great vocal performance by Leonard and in fact one of the best from his whole career. There is real passion in the voice and he never goes off key... well, not too off key anyway. Musically it's wonderful, all restless percussion to drive on the lust and desperation, clear acoustics rattling and a booming bass line. It may be another lament for lost love, but there is such energy to the music that it never becomes down beat at all. Field Commander Cohen has a great feel to it, again with a superb lead vocal and interesting musical backing; bits of piano, acoustic plucking and stabbing strings. Why Don't You Try could have been stripped straight off Songs From A Room, with its wistful vocals, acoustics and jazz bass. The lyrics are wonderful, with Cohen acting as a soother for this woman who has lost her man. There's rhythmic punch to There Is A War, and although very similar in its chord

structure, pace and mood to Lover Lover Lover, there's enough individuality in this to make it worthwhile. The strings for instance are brilliant, with their Arabic style sweeping.

One track here that really does make you think back to the first three albums is the monumental and powerful Who By Fire. Leonard's voice is low and pure, backed up wonderfully by Emily Bindiger and Erin Dickins. There are some foreboding strings too, slams of percussion, tinkling bells and a thumping bass. Unlike the stark material on his first three albums, this song is enhanced by the musical colours painted in by John Lissauer. Anyone to criticise the apparently over the top instrumentation ought to take in the many moods, lights and shades in this track and then think again. There is no song quite like it in the Cohen canon. A brilliant piece of music.

Take This Longing is a soothing, sombre piece with a very low register Cohen vocal and sweet acoustic guitar. Perhaps the oddest and most challenging track on New Skin For the Old Ceremony is its final track Leaving Green Sleeves, his adaptation of the 15th century folk song. Again, his vocals are a little angrier than on other tracks, and it would have fitted in nicely next to Diamonds in the Mine on Songs of Love and Hate. Musically, it's triumphant, with snatches of the Green Sleeves melody appearing on violin throughout, alongside medieval harpsichord, heavenly maidens on backing vocals and lush strings. Cohen begins to shout near the end, as he had at the finale of his first album; a brief moment of horror amidst the varied musical detours.

This album is so full and accomplished in many ways. Musically, Lissauer assured it would be rich and exquisite, especially when strings were in place, and vocally Cohen gave us some of his most simultaneously honest and abstract words, all of which he sang with passion and clarity. One of the finest for sure.

44

EMILY BINDIGER INTERVIEW

Emily Bindiger was a backing singer for Leonard Cohen on the New Skin for the Old Ceremony album, and then joined his merry band of musicians on tour. I asked her some questions about working with Cohen and got some interesting replies to say the least.

Were you a fan of Leonard before you met him?

Oh, absolutely! My older sister started bringing his albums home and I could not stop listening to them. I had just started playing the guitar and I learned every single song. I fell in love with the lyrics and sang all of Leonard's songs and drove my family crazy.

How did you end up getting the singing gig with him?

Well, I actually met Leonard in 1973, a full year before I toured and recorded with him. I had auditioned for a show based on Leonard's poems and songs called Sisters of Mercy, and because I knew all his songs, I aced the audition and got a role in the show. It was first presented at the Court House Theatre in Niagara On The Lake in Ontario, then moved to an off-Broadway theatre in NYC. When it came time to record New Skin for the Old Ceremony my name came up through a few different people and I got the call.

Do you recall your first meeting with him? What was it like?

As I said, I met him in 1973. I had a mad crush, but I was part of a cast of actors and we all just loved hanging out with him. He was very present during the run of the show in Canada and he was just so lovely and available and endearing.

You went on tour with Leonard in 74 and 75. What were some of the best shows you recall?

In Los Angeles, outside the Troubadour, one of Leonard's fans kept yelling up at the dressing room window, "Leonard, I need to talk to you about death!" Leonard looked down and said, "Friend, can this wait? I have to do a show." And when we were in Germany and the intro to The Partisan started, it just seemed that the whole audience was overtaken by this need to try to atone for their country's very ugly past. They cheered on. They were ALL good shows. Leonard can be quite the showman.

What was Leonard like on tour? Any interesting stories to tell?

He was quite gregarious. One time, when our tour bus broke down on a highway in England in the middle of nowhere, he went outside and stood on his head to get people's attention (this was, of course, before cell phones). Another time, we were really hungry after the show and nothing was open. He broke into the hotel's kitchen and cooked a huge meal for us!

Playing live with Leonard must almost be religious. What is the vibe like on the stage with him?

It certainly can be a religious experience. On stage it was playful when it was appropriate but serious when it had to be. We were all in it together, you know? A real collaborative experience.

When going through songs, how much freedom did he give you on vocals? What was the process like getting a song together and arranged to be performed?

We stayed pretty true to what was on the older recordings, because why mess with perfection? And John Lissauer, the musical director at the time, pretty much knew what he wanted to hear in terms of vocals, but there were times that Erin Dickens (the other singer on tour with me) and I worked some stuff out on our own.

What are your memories of recording the New Skin... album?

Here's a story I've never told about that: August 9, 1974. Nixon had just resigned from the presidency, and I was mugged on the subway on my way to the first recording session. I thought, Wow, Nixon and I are both having a bad day. However, the second I got into the studio, and started singing, I felt great.

Which songs did you enjoy from that album?

Who By Fire, absolutely my favourite, because I had to completely copy Leonard's phrasing. I worked very hard on that. But Take This Longing has to be one of my favourite tracks, because the lyrics are so

stunning, and there were two other singers singing harmony besides myself and Erin; Gail Kantor and the legendary Janis Ian and the blend was so beautiful among the four of us.

You've gone on record pointing out Leonard's humour and how he's not this depressing figure. Why do you think people get the wrong idea, because I always pick up on his humour...

Well certainly many of his songs have melancholy and/or an ironic quality (happy songs can be so boring), so I can understand that people must think they mirror his personality. I think Leonard's personality is pretty balanced, like it is in most of us, he just writes so much about the darker side...

What are some of your best memories of working with Leonard?

I will always sound like a fan with a crush when I talk about him. They were all great, seriously. Rehearsing at a studio in the Laurentian Mountains north of Montreal. Being at the Bottom Line in NYC. Leonard jokingly telling people I was underage! Seeing Europe with him. Hanging with the band. I cherish all of it.

What did you learn from working with him?

When you show up, be there 100%. He never gave less than that, in any show. I've learned how to tell the story, how to be completely present in a song and to honour the lyrics.

JOHN MILLER INTERVIEW

The bass player on New Skin for the Old Ceremony talks about working with Leonard Cohen and John Lissauer.

How did you come to work on Leonard's New Skin... album?

I simply got a phone call from Lissauer asking if I was free to work on Leonard's album. I had played bass with a number of folk singers in the 60's and was familiar with some of Leonard's songs but not all that familiar with him as a person. I don¹t remember if we rehearsed first (perhaps at Lissauer's loft?) or if I first met Leonard at the recording studio. He was quiet, well dressed, gracious, respectful and interested. He let Lissauer run the sessions.

Do you recall hearing the playback for the first time?

Other than hearing takes right after we recorded them, I don't think I ever heard the final mix until the New Skin album came out.

What was it like working in the studio with Cohen and company?

The atmosphere in the studio was beyond relaxed, no pressure whatsoever. I believe much of this was based on the connection that Leonard and Lissauer had. You could feel the great respect they had for each other and their shared work ethic. Lissauer brings a subtle sense of humour as well, and as with all great producers; he knew the perfect musicians to bring together.

How were the bass lines figured out for the songs? I'm very interested in the process, and wondered if Leonard and John had any ideas or restrictions for you.

I don't remember exactly how the bass lines were worked out. I know that Lissauer had the master plan as to how the songs should go. I think the bass parts were a combination of what Lissauer wrote and his openness to my suggestions. But what he wrote, clearly showed a great understanding of each song. I'm certain we all wanted to be headed in a direction that Leonard liked, so I¹m sure we were always asking for his input.

Any favourites from the album?

I had no favourite I loved them all. Still do.

Did Leonard seem satisfied with the shift in sound from his earlier records? This one really did feel like a breath of fresh air.

I wasn't familiar with Leonard's earlier albums at that time so I had nothing to compare them to, nor was I privy to discussions Leonard had with Lissauer. I can only assume that if Lissauer said we should move on to the next tune, that meant that Leonard was happy.

What is it like actually playing a Leonard Cohen song with Leonard Cohen himself? I'm kind of in awe of that idea. A lot of people have said it's on a different level playing music with him...

I've told my musician friends that I hope they all get a chance to record a tune with Leonard. It's an opportunity to play as few notes as possible. There's a lot of talk about less is more, but with Leonard it's not talk. It's like his music welcomes you into that space between the notes. Playing his music always made me feel I was within a haiku poem. It resonated with me.

So you remain a big fan of the album?

It's one of my favourites and my wife Connie's absolute favourite.

You've played bass for so many different people, from Madonna to Michael Jackson, so how could you sum up the process and the whole experience of making an album with Leonard Cohen, more of a minimalist, than the other artists you've recorded with?

After that record, I toured with Leonard for a few years. The first tour was with Lissauer as the Musical Director: no one better. He wasn¹t available for the second tour and Leonard asked me to be the MD. One of the most profound times of my life. Often after a concert, when we'd be back at the hotel, Leonard and I would go out and explore the underbelly of each city. While I didn¹t know much about Zen at that time, I know those late night adventures with him and the sense of no agenda and pure spontaneity combined with the depth of his music, resonated powerfully with me. I'm sure on some level, that my time with Leonard led me to the world of meditation and to my 25 years of continual study of the Japanese Tea Ceremony.

If the phone were to ring right now and Leonard were to ask if I could play with him, I'd be there so fast I'd have to apologize to you, because I wouldn't be able to finish answering your questions.

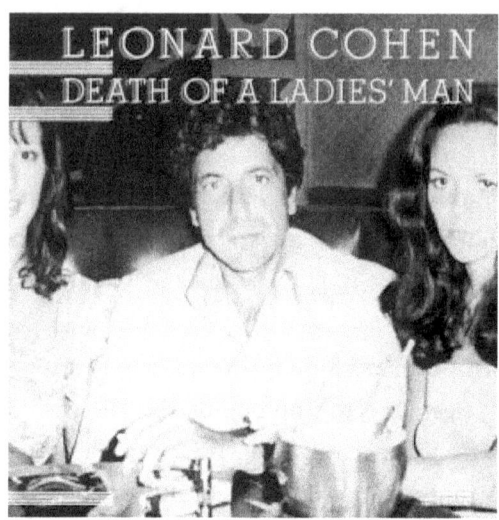

DEATH OF A LADIES' MAN (1977)

The oddball entry in Cohen's discography, the Phil Spector produced Death of a Ladies' Man, is definitely an acquired taste. For those used to Cohen's subtle, poetic acoustic ponderings, the brash, in your face, often tacky wall of sound style used by Spector is too much to bare. I must admit, it took me a while to get used to this record, but once I looked beyond the two mismatched gentlemen in charge of operations - and indeed the rather strange time which was had in making it - I was able to accept it on its own bizarre terms.

Spector was a loose cannon with a fondness for guns and chaotic recording sessions, as so often documented in the making of John Lennon's Rock and Roll album which the diminutive producer had over seen. People had warned Cohen off working with him, but a creatively weak Leonard caved in and agreed to start the record with Spector. He would perhaps live to regret the decision.

"It was one of those periods when my chops were impaired, and I wasn't in the right kind of condition to resist Phil's very strong influence on and eventual takeover of the record," Cohen told Mojo Magazine years later. "There were lots of guns around in the studio and lots of liquor, a somewhat dangerous atmosphere. He had bodyguards who were heavily armed also. He liked guns - I liked guns too but I generally don't carry one, and it's hard to ignore a .45 lying on the console. When I was working with him alone, it was very agreeable, but the more people in the room, the wilder Phil would get. I couldn't help but admire the extravagance of his performance, but at the time couldn't really hold my own."

In another interview, this one with Uncut, Leonard claimed that his own performance on the record left a lot to be desired. He said his marriage was on the rocks, and his lack of confidence in song writing led him to working with Phil. "Otherwise I could not have written with Phil because I was never a great collaborator," he added. Cohen was convinced though that Spector could bring his work into the rock n' roll arena, give it rhythm and a proper beat. He was kind of right.

Art Munson was one of the guitarists on the album, but these days he can't seem to recall which songs he was actually on. "I was aware of Leonard but not particularly a fan," Art told me recently. "I was working on the John Lennon Rock and Roll album with Phil Spector. There was no real interaction (with Leonard). I was a studio musician and you are basically a hired gun that goes from job to job."

And his personal view on Spector and the atmosphere in the studio? "Spector was pretty much in control as he liked to be," he says. "I always enjoy playing music but I don't remember the songs. The atmosphere was pretty relaxed considering it was a Spector production. Spector was a larger than life character and usually there was a lot of chaos around his sessions. Not so with this album."

No matter what the atmosphere was like during recording, the resulting album is both confusing and confused. Cohen's voice sounds awkward over the brash instrumentation and even though the songs are clearly really good, they would have been better executed under the supervision of someone like John Lissauer.

"The LP probably has fewer admirers than buyers," Rolling Stone wrote, who curiously could see the problems with it but enjoyed the album's eccentricities. "Cohen himself, though he feels the songs are unusually strong, has expressed severe dissatisfaction with the record. Spector, it seems, simply took what the singer felt were tapes still in progress, kept them under lock and key, mixed them like a solitary mad genius and released the album without bothering to consult with his artist. Not everyone likes a surprise, but Cohen has both dealt out and dealt with enough super romantic irony in his lifetime to walk through it as if it were a fine spring rain. With such a history, it's fitting that Death of a Ladies' Man more than lives up to its notoriety. It's either greatly flawed or great *and* flawed — and I'm betting on the latter. Though too much of the record sounds like the world's most flamboyant extrovert producing and arranging the world's most fatalistic introvert, such assumptions can be deceiving."

From the opening bars of True Leaves No Traces, it is clear that this is a Phil Spector album, not a Leonard Cohen one. Perhaps it started as Cohen's, but was hijacked by Spector who ran to the hills with it. The melody Cohen sings with the backing singer is beautiful and as dazzling as the Austin Powers-esque music is at times, in all it jars with Cohen's low voice and subtle lyrics. Still, there's some nice flute and string work here, but there's simply too much going on; plus it sounds a bit like it should be the soundtrack to a 70s soft core porno.

Songs like Iodine don't work at all in my view, with the awful echoey drums and vocal, not to mention the sleazy backing music. Paper Thin Hotel is one of the album's better cuts, but the effects put on to Cohen's voice ruin all the seedy glory of this voyeuristic piece.

Memories is just too bombastic and hellish to enjoy, with so much music and vocals going on that it all becomes a bit too much. That said, Cohen himself gives the vocal some real effort and comes out as the best thing on this shambles. I Left A Woman Waiting is another stand out, with fine Leonard vocals and some wonderful lyrics. Again, the music is over cooked, but here it kind of fits the melancholic feel of the lyrics. One of Cohen's best song titles ever is next, Don't Go Home With Your Hard-On, but it's definitely not one of his best tracks. In some ways, the crowning moment is the closing title track, in all its 9 minute glory. Bringing to mind some of Spector's more reserved production for George Harrison, there's a fine double tracked Cohen vocal that sends shivers down the spine and some subtly played out music; twinkling pianos, sturdy drums, holy choir backing and loose acoustics. Definitely the one cut worth the price of the album.

Cohen was right when he said that the songs got away from him. The big shame about Death of A Ladies' Man of course is that there are some lovely tracks on it, but they'd have been much more effective on a standard Cohen album. They'd also have dated a little better too.

N°131 decembre 77 6 F mensuel

rock & folk

COHEN ROCKER?
**STEVE HILLAGE
ROBIN TROWER
RICHARD HELL
STEELY DAN
EDDY MITCHELL
DICO REGGAE
TUBES
YES**

suisse : 4,20 fs portugal : 50 esc canada : 1 $ 10

RECENT SONGS (1979)

In between the making of New Skin... and Recent Songs, Cohen had started a project with John Lissauer called Songs for Rebecca, and although the album was abandoned, some songs survived and ended up on Recent Songs. Seen as kind of a return to older territory, Recent Songs itself shares a lot in common with his earlier, more folk orientated work, and thankfully veers in the completely different direction to what we heard on Death Of A Ladies' Man. Pairing himself with Henry Lewy as joint producer, it's a much clearer and enjoyable album and there are no cringe inducing moments as on Spector's bloated effort, so that's a bonus too. What you get is Leonard Cohen perfectly framed in the kind of setting that suits him the best.

From the start of The Guests, one thing jumps out at you; the fact that Cohen's vocals sound clearer and more assured than ever, his voice much warmer and properly placed in the mix. Yes it's still quintessential melancholy Cohen, but there is a restrained enthusiasm

here absent from other works. The gorgeous gypsy violin by Raffu Hakopian adds some colour, as Scarlet Rivera did to Dylan's poetry on the Desire album only four years before this record. The Guests is one of Cohen's finest album openers, in that it combines the odd mix of a sad, descending verse with an upbeat, uplifting chorus. There are some stunning backing vocals by Jennifer Warnes and Sharon Robinson, and the acoustic guitar work is particularly strong too. The song itself is an adaptation of a 13th century Persian poem, and as unlikely as it seems, they couldn't have started the record off nicer.

The album eases into its unusual second song, Humbled in Love, with Cohen speak-singing over a charmingly dragging jazz backing track. The music is absolutely beautiful on The Window, with that heart tugging violin aside the Spanish style guitar work. Cohen's up close and weary vocal delivers the poetry with effortless charm. Again, the jazzier element returns on the cool and smooth Came So Far For Beauty, with Leonard sounding like a half drunk old lounge lizard leaning off the piano in a tux, tie undone and drink in hand. It does conjure up a mood of its own in the Cohen canon, with the tinkling pianos and low bass plucks.

One of the most peculiar songs in Cohen's catalogue is The Lost Canadian, a traditional song performed in slanted, jaunty Mariachi style. For Cohen to select an old French Canadian song, it's no surprise he chose one that had references to death. Sung in its original tongue by a convincing Cohen, he adopts anther character, this one of the defiant troubadour singing out for those who were put to death after the Rebellion in the late 1830s. The sombre trumpets work wonderfully atop the shuffling rhythm. Cohen again delivers a sublime performance, and on Recent Songs it becomes apparent he is almost the actor-in-song, slipping into eras and personas with surprising ease.

He gives another perfect vocal effort on The Traitor, a gentle acoustic and violin led piece that makes space for Cohen's voice, filling the centre of the track completely. Our Lady of Solitude is a curious one that mixes Cohen's appealingly flat tones with gorgeous jazz bass, loose percussion and even some surreal keyboard sounds.

Next up is The Gypsy's Wife, one of his most celebrated tracks of this era. In the documentary The Song of Leonard Cohen, he spoke about the writing of it. "The Gypsy's Wife was one of the last and swiftest songs I've written," he said. "I started it in Los Angeles around the time I began recording Recent Songs, which was last March or April [1978], and the song was ready in about three months. And, of course, my own marriage was breaking up at the time and, in a sense, it was written for my Gypsy wife, in other words the wife that was wandering away. But in another way it's just a song about the way men and women have lost one another, that men and women have wandered away from each other and have become Gypsies to each other. The last verse says 'There is no man or woman you can touch. But you who come between them, you will be judged.' In other words, even though we are in the midst of some kind of psychic catastrophe it's not an invitation to take advantage of it, and that's mostly what the song is about."

It claws and grasps towards defining that hopeless, sad feeling when a relationship is all but over, with one soul wondering where the other is and just what they are doing out there on their own, knowing that heart is no longer theirs. It's a depressing song no doubt about it, but the melody and musical arrangement work so well together that you can't resist it. Regardless of the fact it's about Cohen's own marriage breaking down, the song is open for all of us to put our own thoughts into it. It's not the best song to hear when you're going through a

separation, that's for sure, but if you're feeling OK, it's just another precise and soothing dose of Cohen melancholia.

My favourite song on the album is The Smokey Life, with its bare arrangement and imaginative flowing chord sequence and melodic complexity. It's so cleverly constructed and full of winding shifts that you look forward to every time the melody drifts towards its next neatly structured phase. For a poet who came to song writing later on (well, in his early thirties, which was old back in the 60s), he mastered song craft in his own way quite impressively and this song is a perfect example of that. Ratso Sloman, the famed journalist, once said that Cohen and Dylan were very similar as song crafters, but that Cohen was technically more gifted. I can perhaps see his point.

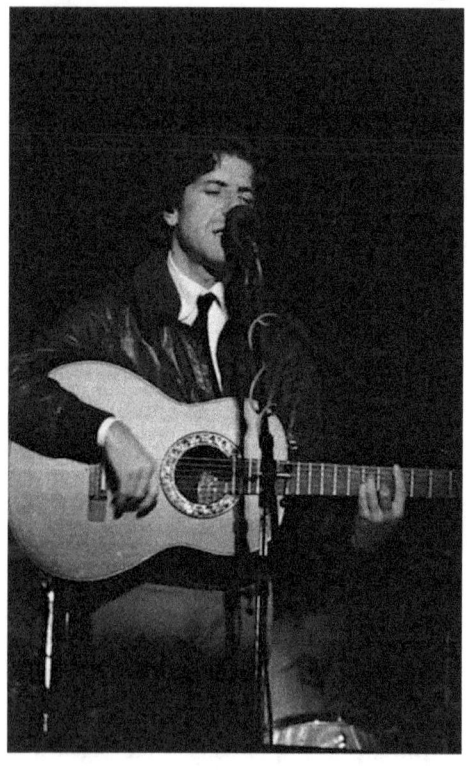

The album closer is Ballad of the Absent Mare, which is reminiscent of Songs of Love and Hate, with its raw, occasionally out of tune vocal. There's an old Western feel that changes the mood, punctuated by the Mariachi trumpets in the distance and the sweet violins. It's a fitting end to one of Cohen's most musically varied and interesting albums.

"I think I like Recent Songs the best," Cohen told Sylvie Simmons in Uncut Magazine. "The producer was Henry Lewy. Joni Mitchell

introduced me to him. He had produced several of her early records. He had that great quality that Bob Johnston had: he had a lot of faith in the singer and he just let it happen."

"The grotesque beauty of Cohen's last LP, Death of a Ladies' Man — for all that album's flaws — was a step in the right direction," wrote Rolling Stone in their album review. "Though he took the task too far and too literally, producer Phil Spector shoehorned the singer into an alien tradition: American rock & roll. Cohen's spoke-song style actually cleaves more to the European cabaret tradition; he's less a developed folkie than a more mordant Jacques Brel, or the Charles Aznavour of the apocalypse. If Death of a Ladies' Man captured the large-scale metaphor, with the music serving as the artist's canvas for struggle, Recent Songs goes a step further. Leonard Cohen has finally learned to use music as another kind of paint."

Recent Songs was widely seen as a return to form after the rather odd Death Of A Ladies' Man and you can see why. The music and lyrics are all the best they can be, arranged with the kind of subtlety and tastefulness that could have made the songs on Death Of A Ladies' Man much more effective. As great as Spector could be in his field, as long as he had the right performer, his approach just didn't work for Cohen. Lewy however had that restraint and consideration for an artist such as Cohen, where he was keen to colour in the landscape but knew that the singer-songwriter is always the focal point; or indeed the hero on horseback going off into the sunset, as Leonard appears to be on the closing bars of this album. This is certainly his most filmic set of songs, delivered cooly with the vivid, descriptive lyrics and the unexpected, enigmatic sounds. No wonder Leonard likes this one the best.

VARIOUS POSITIONS (1984)

"When you are gathering songs together," Cohen said to Malahat Review, explaining his new LP's title. "The ones you have and the ones you can finish, they generally fall around a certain position and this position seemed to me like walking, like walking around the circumference of the circle. It's the same area looked at from different positions. I like to have very neutral titles. My last album was called Recent Songs and that was the most perfect title I've ever come up with. But Various Positions is OK."

Leonard Cohen has often stated how much he loves the sound of a female vocalist and how singing alongside one softens his own particular style, thus making him more comfortable and at ease with the material. On Various Positions, released five years after his last record, Jennifer Warnes returns to the fore and puts her mark on the record as much as Cohen himself does. It's still definitely trademark Cohen throughout - the dual male/female vocals, sombre style, sad

lyrics - but his embracing of the 1980s meant that he would toy with keyboards and move his own unique style into the next decade. Somehow, that deadpan, low registering, barely even singing tone worked wonderfully in the synth soaked 1980s.

In truth, Cohen had taken a break from writing and recording in the year building towards the record, instead visiting his kids in France and relaxing as much as he could. He also toyed with acting, starring in a TV musical called I Am A Hotel. He reunited with New Skin... producer John Lissauer and the pair set work on a new album. Recorded in New York at Quadrophonic Sound, Cohen enjoyed the new direction and relished the freedom of switching on a Casio keyboard and working his ideas on top of a steady beat.

"It was the first time I could really see and intuitively feel what it was I was doing, making or creating in that enterprise.," Leonard told Globe and Mail. "After a long period of barrenness, it all just seemed to click. Suddenly, I knew these weren't discrete songs I was writing... I could see - I could sense a unity. Various Positions had its own life, its own narrative. It was all laid out and all of a sudden it all made sense. It was almost painfully joyful, if that makes some sense. The pulling and the putting of the pieces together coherently, the being inside of that process and knowing, once I'd done that, it would be finished and I would have to leave it and go back to the world."

The enjoyment he had in making the album is evident from the start of the album's opening track, one of his finest songs, Dance Me to the End of Love. Although the keyboard beat and synth sounds have aged, they also fit the song nicely. The heavenly female vocals come in the mix strong, making way for an echoey Cohen, sounding more soulful and enthusiastic than ever. Although there are better versions of this by Cohen himself (in particular a Jools Holland live performance in the 1990s, which is simply amazing), it's undeniably a classic; the

infectious, irresistible melodies, the fresh synth sounds and the lyrics all combine to make it neatly crafted and tidily produced.

"Dance Me to the End Of Love... it's curious how songs begin because the origin of the song, every song, has a kind of grain or seed that somebody hands you or the world hands you and that's why the process is so mysterious about writing a song," Cohen later said, speaking of the song's genesis. He also said in as much that everyone need not take the literal definition of the song as the only interpretation. Cohen knows as well as any that songs are universal and open for all manner of mood and occasion. "But that came from just hearing or reading or knowing that in the death camps, beside the crematoria... a string quartet was pressed into performance while this horror was going on. They would be playing classical music while their fellow prisoners were being killed and burnt. So, that music, 'Dance me to your beauty with a burning violin,' meaning the beauty there of being the consummation of life, the end of this existence and of the passionate element in that consummation. But, it is the same language that we use for surrender to the beloved, so that the song — it's not important that anybody knows the genesis of it, because if the language comes from that passionate resource, it will be able to embrace all passionate activity."

Coming Back to You is glorious, with its sweet piano, electronic drums and warm, up front vocal effort. It's one of my favourite songs of his from the 80s catalogue, as it shows his lesser recognised positivity and also his lighter qualities. Songs like The Law work tremendously well, with their lush production and musical flare, while the gentler Night Comes On is like an alternative lullaby to get you off to sleep. Cohen's voice sounds brilliant here, while the female voices are mixed so sweetly that they sound like ghosts in the distance reaching out from beyond.

Probably Cohen's best known song is Hallelujah, and it's also definitely one of the most covered tracks of all time. Although many would go for the famous Jeff Buckley version, I always strongly preferred this one, with its vast choir, soothing keyboards and honest Cohen vocal. His performance lacks the schmaltz and forced emotion so evident in other versions (not Buckley's I might add), while his voice is still warm and appealing, despite the lack of vocal acrobatics that some of the others will undoubtedly give it. So here it is, from the mouth of the man who wrote it, pure and simple with effective musical accompaniment.

At the time, it was just sitting in there on the album alongside all the other tracks, on a record which the label had no faith in and one that took its time to get out there into the public's consciousness.

Famously, Cohen wrote 80 verses for the song before settling on the lyrics we hear on the record, so for him it was always a special song. It was a long and arduous process putting it together, with its biblical references and less penetrable verses, but it was worth it in the end, even though Cohen probably hurt his noggin when he was banging it off the floor in frustration during one particularly intense writing session. Even after hearing it all these times, its beauty is quite overwhelming.

The song's journey has been long though. It started off unknown, was picked up and covered by a few artists and has now become something of a sing along anthem standard. You hear it everywhere now, even on the bloody X Factor. It's heard so much now, in its various different guises and forms, that you could be forgiven for forgetting the brilliance of the original.

"I was happy that the song was being used," Cohen said of the world's obsession with his creation. "Of course, there was certain ironic and amusing sidebars because the record that it came from, which was called Various Positions, that record Sony wouldn't put out. They didn't think it was good enough. So there was a mild sense of revenge that arose in my heart. I was happy about it but it's... I was just reading a review of a movie called Watchmen that uses it, and the reviewer said, 'Can we please have a moratorium on Hallelujah in movies and television shows?' And I kind of feel the same way... I think the song came out in '83 or '84, and the only person who seemed to recognise the song was Dylan. He was doing it in concert. Nobody else recognised the song till quite a long time later, I think."

When inducted into the Songwriters Hall of Fame, Cohen offered a little insight into his original aims with the song. "I wanted to push the Hallelujah deep into the secular world, into the ordinary world," he said. "The Hallelujah, the David's Hallelujah, was still a religious song. So I wanted to indicate that Hallelujah can come out of things that have nothing to do with religion."

It seems funny continuing on to the rest of the album after such a massive, monumental song, but there is also fun to be had in the lighter country feel of The Captain, despite the lyrics referencing two of his "favourite" subjects, the crucifixion and the holocaust. Hunter's Lullaby is an over looked gem, with some psychedelic keyboards and a great set of lyrics sung with warmth. Heart With No Companion is a nice shuffling ballad, with acoustic guitar and a full vocal, but the LP closer If It Be Your Will is certainly more memorable, a haunting Cohen-Warnes duet over a haunting musical back drop.

"It's true that Cohen's vocal range will never rival Cleo Laine's," wrote Rolling Stone in their review, "and his songs will never be featured in the repertoire of Up with People. And I have to admit that

Various Positions is less satisfying than Recent Songs or New Skin for the Old Ceremony (though superior to Death of a Ladies' Man). Still, Cohen's insistence on adapting classical poetic forms to the contemporary pop art song and searching for fresh lyrical imagery within a confessional voice has had an important influence on a whole generation of pop composers, and anything he does is worth hearing."

Critical reviews at the time were OK, but didn't reflect the true beauty of this record. In truth the 1980s were a hard time for singer songwriters who had made their name in the 1960s and 70s. The speedily moving technological advances, many of which were passing fads, and of course the major label's submission to the pop "product" market ideology, meant that people like Bob Dylan and Neil Young felt alone in the wilderness, battling with the suits at the label and the changing pop landscape. Cohen however, never too concerned with record sales and his saleability (to his credit of course), was able to adapt himself with ease to the times and continue to appeal to his cult fan base. If anything, the 80s see Cohen brighter than ever and Various Positions is solid throughout. His voice is strong, full of a calm optimism, brought out by Lissauer's sympathetic production style. The music is very mid 80s but it still works, sounding of its time but also detached from that shoulder padded, mullet haired era. Cohen is confident, delivering his lyrics in a casual manner. Gems come from his mouth so often on this record that you almost get used to his brilliance and maybe even take it for granted. There's no shame in saying he's one of the finest lyricists we've ever had and Various Positions has him at the peak of his powers. Thankfully now, it's one of his most acclaimed and popular albums; and so it should be, as it's one of his definitive works.

JOHN LISSAUER INTERVIEW

Acclaimed composer, musician and producer John Lissauer has been involved in countless landmark music projects, including scores for films like Seven and Watchmen, as well as working twice with Leonard on both New Skin For the Old Ceremony and Various Positions. Here he talks about working with Leonard Cohen.

What were you doing before you worked with Leonard?

Before I met Leonard, I had produced and arranged a number of records for various artists. Al Jarreau was among the first guys I worked with while I was still in college; there were a few other artists that I was working with in those days, kind of learning the studio techniques, experimenting with instrumentation. After I graduated, I moved to NYC and commuted once a week to teach music

composition at Yale. That just lasted for a year, after which I devoted myself to composing, arranging and producing. I took on the job of arranger and Music Director for the re-formed Manhattan Transfer and brought them to Montreal to sing backup on some recordings with A&M artist, Lewis Furey. That was where I met Leonard.

Were you a fan of him at all before working with him?

My girlfriend at that time was a big fan! I knew who he was, of course, and I was aware of some of his work - Suzanne, Sisters of Mercy, etc.

How did working on New Skin... come about? And do you recall your first meeting with him?

I had just finished Lewis Furey's first album, and we had put together a really great band for a series of performances in Old Montreal at the (then) famous Nelson Hotel. The shows were sold out and the performances were electrifying. The whole town was buzzing about this new "breakout" artist. Lewis had known Leonard for a few years and was, I suppose, his protégé. Well, one night after the show, this quiet gentleman in a dark suit came over and softly introduced himself... it took me a moment to recognise him and make the connection. He said he was impressed with the record that Lewis and I had made and that he would like to meet me in NYC in a few weeks. He came to my loft/studio on 18th street, he played me some songs, we talked for a bit and hit it off beautifully. He then introduced me to John Hammond of Columbia Records, who had signed him. I got his seal of approval, and we just started recording. It was that simple. Shocking, really, how effortless the entire recording was.

What was your role on the album, as in on a day to day basis? And what was the musical relationship like between you and Leonard?

Well, since I was the producer and arranger, I worked with Leonard on the songs a bit before hiring the musicians and singers and bringing them into the studio. At Hammond's request, we started the recordings at Columbia Studios, but the environment and vibe weren't that great so we moved the recordings to Sound Ideas Studios with Rick Rowe engineering, assisted by Leanne Ungar, who quickly became my favourite engineer, and with whom I have worked for decades; one of the finest engineers on the planet. We recorded most of the songs with LC playing guitar on the basic tracks, surrounded by the best, most sensitive musicians I knew. We used some rather exotic percussion (at that time) and some very colourful other instruments on these tracks, which pulled the recording away from the tradition "folk" sound that Leonard's audience had become accustomed to. I also tried to frame the records with overdubs (strings, low trombones, clarinet, etc.) that gave the record a very "visual" quality. LC and I discussed every aspect of these arrangements, though I would occasionally surprise him with some late-night inspirations. We both inherently knew what worked and what didn't, and we seemed to agree on all phases of the recording. As I said, it was an inspiring and exciting process, but also effortless in the way the work just seemed to flow together. We were on the same page from start to finish.

What were some of your favourite cuts on that album to arrange?

Oh man, it's been about 42 years. I have to think about this one. Of course, there were the two somewhat middle eastern sounding songs: Lover Lover and There is a War with some driving rhythms and new colours for Leonard's music. I also remember arranging some interesting rhythm stuff and vocals on Who by Fire. I think he still performs this arrangement, as is, in his shows to this day. So many great memories of this album; the loping sepia-toned I Tried to Leave You, and the introspective Chelsea Hotel, of course. I remember The Singer Must Die became very visual in the orchestrations. The whole album had a certain feel to it that was very rewarding. Leonard and I were very happy with the process and the result.

You then accompanied Leonard on those gigs through 74 to 76, a golden period in Cohen's career. What were some of the most memorable experiences you had touring with him?

In Paris, we were among the performers at the Fete de L'Humanite, an outdoor event with an audience of a half-million. We played behind a plexi-glass protective shield, because of some earlier gun-fire. It was a festival of various factions of the communist and socialist parties, so, although we drove to a nearby area in limos, we got out and crammed into a few beat-up old Renaults to get to the staging area. We had to keep up appearances. The Wall was still up in those days, and Berlin was fascinating. I remember having an abbreviated sound-check because some guy named Van Karajan was still rehearsing the Philharmonic. Our reception throughout all of Germany was astonishingly warm and wildly tenacious. Every night we experienced their unquenchable thirst for encores. In addition to the European tours, we did two shorter North American tours. A real highlight for me was our first trip to LA, where we were joined by Dylan, Joni

Mitchell and David Crosby. They showed such respect and a near reverence for LC; it was amazing. And this was in '75, way before any of the Hallelujah hysteria.

Ten years later you were the arranger on Various Positions. How did you come to work with him again after ten years?

Actually, very few people know this. Leonard and I began to co-write an album to be called Songs for Rebecca in 1976-7. We recorded 6 new songs and a new version of Diamonds in the Mine. The project was put on hold for a bit while LC went to Hydra, and then his manager, Marty Machat convinced him to do a record with Phil Specter... and that was that. We never went back to it. One of the songs we wrote together, Came so Far for Beauty did get released on Recent Songs a few years later in its original recorded form. In 1984, Leonard called me out of the blue and asked me to produce and arrange Various Positions. Hadn't spoken with him for about 7 years, I guess, but we just jumped back in the studio, as if we'd never left. That's the way it is sometimes. I have rough mixes of the Songs for Rebecca record.; maybe one day they'll get released!

Do you remember first hearing those amazing songs?

Well, the way it worked (with us, at least) was that Leonard would play me a few songs at a time, and I would start to learn them, and digest them. He had just bought a little Casio keyboard (this was 1984, remember), and he loved being able to push a key and it would play a simple drum beat and bass notes; that's how he played Dance Me to the End of Love the first time. I was in his room at the Royalton when

he played me Hallelujah the first time and I think also If It Be Your Will. What a pair of great songs!

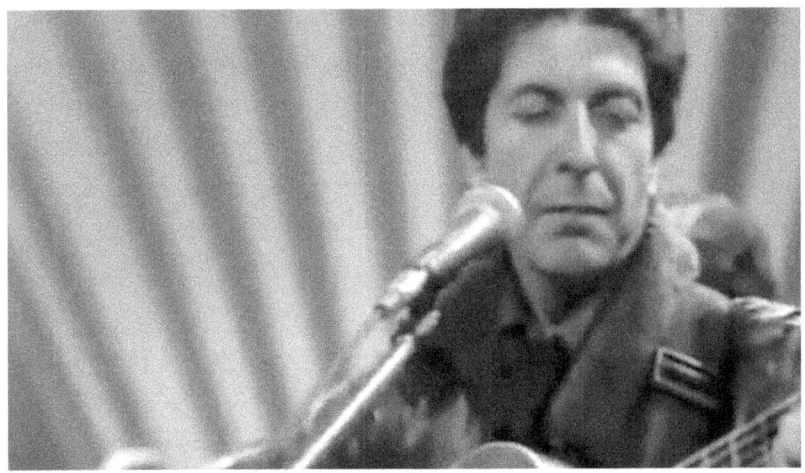

What was the process like arranging Hallelujah? Did you know you were making a special song?

CBS Records really wanted Leonard to get some airplay in the States; they wanted a hit record. I really thought we had a major hit anthem with Hallelujah as soon as we started working on it. I sat at the piano with LC playing his nylon guitar and it just flowed together. I helped out a bit with the chords, and LC experimented with different verse orders, then we were in the studio recording it in a matter of days. It took shape quickly and the arrangement nearly wrote itself. We were in that zone. Instead of using a gospel choir (too obvious and limiting) or a children's choir (too precious), it seemed like a good idea to me to use a combination of singers; men, women, ordinary and extraordinary, to give it a "people's" feel. Down-to-earth and joyful! We wanted Leonard to have a larger than life quality, with a lot of sonic space around him, so we kept the opening very simple and direct. We really thought we had made a very special LP with

Hallelujah and Dance Me... as the cornerstones. Imagine my shock and dismay when CBS (in their infinite wisdom) hated the record and refused to release it. It was years before it had a soft release in Europe, and eventually built up a following and got a US release. It turns out we were right after all. It is one of LC's most successful albums.

One of my favourite songs by Leonard is Dance Me to the End of Love.

As I said earlier, LC was so enamoured with his Casio rhythm machine, that we used it as part of the basic track. We were recording the record with some of the members of a band called Slow Train, and, when we combined both elements, it became kind of upbeat and catchy. He uses this arrangement to open most of his concerts to this day. Unfortunately, when we did the record in '84 LC's fascination with the Casio and my interest in the new Synclavier were on display here, and in retrospect I'm sure we both would have loved for it to be more organic and less electronic. More of a real band with a gypsy's violin and clarinets would have served the record better. But Jennifer Warnes' duet with Leonard is beyond reproach - exquisite, in fact! As it is in If It Be Your Will, an artistic achievement for the ages.

How had Leonard changed in those ten years, musically and as a songwriter?

He was a genius when I met him, and incredulously, he just keeps growing and evolving. His chordal and melodic "palette" has evolved and matured over the years, while still being identifiable as Cohenesque. His lyrics (as well as his poetry) are inspiring, provocative, and, as always, open to many interpretations. There is often an extremely

personal and vulnerable quality to his writing, which, when combined with his craft and mastery of nuance, reaches a level of rarefied excellence. This, too, has grown over time, but has always been personal and powerful. I must add that, in addition to his genius, he has somehow managed to remain kind, compassionate and generous.

Compared to the film soundtracks and other great artists you have worked with, how does it differ arranging and producing Cohen?

When you are composing for film, you are "scoring" to the action, dialogue, "scenic vibe" and other cinematic demands. There may be thematic elements, but rarely (these days) is film scoring "song"-based. When producing and arranging for any recording artist, working with that singer's artistic vision and the demands of each song are the most important things. We often try to add a cohesive quality to the songs, making the whole CD fit together, as opposed to sounding like just a collection of songs. But sometimes not! The idea of a concept album still exists, but often, each song is given its own personal stamp, regardless of the other songs. With single digital downloads dominating the industry these days, we're seeing the hit single approach applied to more and more of the recordings. Through my decades of working with Leonard (we last collaborated on Anjani's Blue Alert album for Sony) our musical approach has most often been in sync. Even when we have had a slightly different view of a songs' setting or arrangement, we've always found our common path in a joyful, effortless way. What a pleasure it has been.

I'M YOUR MAN (1988)

Cohen went full-on, euro synth pop for I'm Your Man, an enjoyable album that was another sharp turn for Leonard. Although Roscoe Beck, Jean-Michael Reusser and Michel Robidoux all do a good job, having a few different people in charge of recording means that I'm Your Man often lacks the unity that John Lissauer gave Various Positions. But it makes up for its lack of complete sonic focus by being one of his most musically adventurous and varied albums. The use of electronics, keyboards, synthesizers and even the Synclavier means that although I'm Your Man is VERY 1988, it stands mightily in that era as a prime example of what a great songwriter could do with the technological advancements of the time. In a word, they were used as the tools rather than the tool bench. Song wise, the structures, mood and style are very similar to his earlier - and indeed later - work, the only thing being different is the synthy landscape he is singing amidst.

But it works somehow and I'm Your Man has some really solid material on it.

The chilly sounds of First We Take Manhattan, cinematic and atmospheric, open the album in suitable style, with Leonard sounding impassioned and bold. For a song about terrorism and the threat of domination through force, it's as spookily relevant now as ever before, more so in fact. "I think it means exactly what it says," Cohen himself said. "It is a terrorist song. I think it's a response to terrorism. There's something about terrorism that I've always admired. The fact that there are no alibis or no compromises. That position is always very attractive. I don't like it when it's manifested on the physical plane - I don't really enjoy the terrorist activities – but Psychic Terrorism. I remember there was a great poem by Irving Layton that I once read - I'll give you a paraphrase of it - it was Well, you guys blow up an occasional airline and kill a few children here and there, he says. But our terrorists, Jesus, Freud, Marx, Einstein. The whole world is still quaking..."

Ain't No Cure For Love is one of his most tender and cleverly executed lovelorn ballads, a true sentiment in its title alone; love can feel like a disease, especially when only one of the party is locked within it, or when the "infected" wishes to be freed from this dark, dangerous love. Everybody Knows is another solid song that works brilliantly in this synth guise. Like all good songs though, it would work in any form (Cohen himself has revisited it again and it always works effectively). A collaboration with singer Sharon Robinson, it's a smart monologue over a wonderfully played arrangement.

The title song, again crooned over a keyboard beat and some cheesy but appealing synth lines, is a bona fide Cohen classic; romantic, moody and committed, it's one to set the female fan's hearts racing

like mad. The words also work well on paper, read out alone in their isolated form, but they really come to life on top of the music.

Leonard Cohen, the doom and gloom reaper of the late 60s and early 70s, is no more throughout much of I'm Your Man, despite some of the darker subjects in discussion here. The humour so evident in his poetry (in particular his later Book of Longing book), is very present; it's subtle but noticeable. Take the quip on the song's finale, Tower of Song, for example; when he says he was born with the gift of a golden voice, we can't help but smile. Here's the man who's had to put up with critics and Cohen skeptics repeatedly saying how out of tune and boring his voice is. As a result, the humour on I'm Your Man makes more of a lasting impression than the blackness.

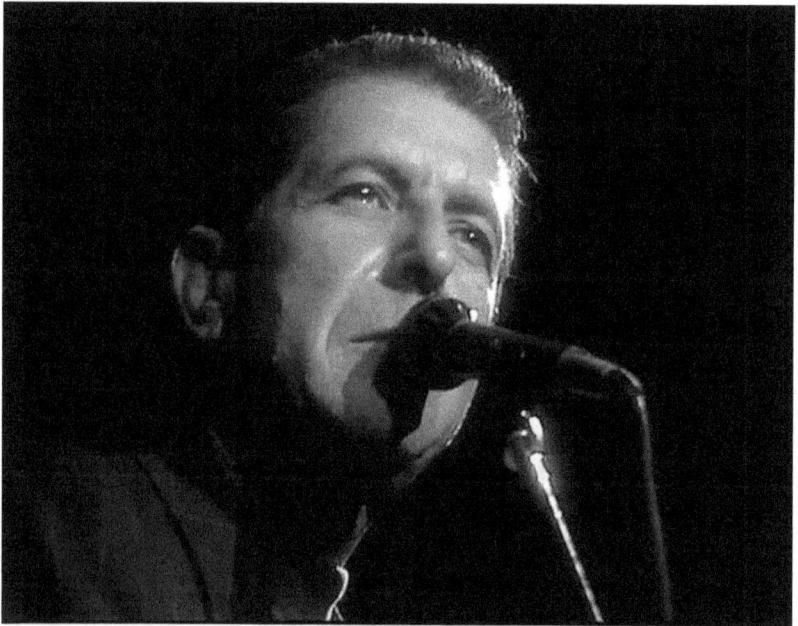

I'm Your Man didn't do so well in the US, but like his other releases it did well in Europe. The album definitely fit the current European psyche at the time way better than what was going on in America.

Asked by Tom Schnabel if he was surprised by its European success, Cohen replied "Well, you hope but you never expect. I'm grateful to have an audience anywhere. The audience in Europe is wide. I seem to have struck deep into some of the countries. I have small pockets of listeners in America. I like singing in the United States because my language comes out of this language and people can follow the real meaning of the songs. I use the cadences and rhythms of the American language. I know that in Norway, for instance, or in Scandinavia where English is a second language, there still is some kind of translation process going on."

This really was the first wave of mass appreciation for Leonard, and while the post 2000's and onwards resurgence in interest is much greater, the late 80s were a good time to be Cohen too. "As second comings go," Rolling Stone observed, "there probably isn't a less likely one than that of the Canadian poet and singer-songwriter Leonard Cohen. Though his kind of confessional romantic despair would appear to be hopelessly passé in the Eighties, it has instead proved to be an inspiration to a new generation of singer-songwriters. While keeping the focus on his ever flatter but exceptionally charismatic voice, Cohen has fashioned an unabashedly contemporary record steeped in austere synth pop. It's a pleasure to say there's still absolutely nothing comforting about having Leonard Cohen around."

I'm Your Man is a very slick album, from its hilarious cover photo of Cohen still looking cool even with a banana in his mouth, to the laid back euro pop feel throughout. It's an album that, if you're more familiar with the acoustic doom balladeer Cohen, will likely make your jaw drop upon first investigation (it did for me when I first bought the CD). But it's a real grower, full of hidden depths and subtleties that reveal themselves later on. And once you get comfortable in synthy Cohenland, you'll find it hard to leave.

THE FUTURE (1992)

There was another four year gap in between the glorious I'm Your Man and the release of 1992's The Future, but in those four years a lot was happening in Cohen's personal life. His son Adam was getting over a car accident (he was initially in a coma) and he was seeing Rebecca De Mornay, an actress most known around this time for the thriller The Hand That Rocks the Cradle. In fact, De Mornay was a valued collaborator on this record and it can arguably be said that she added a lot of new fresh colour into the mix. The Future was recorded over six months in 92, in several locations including LA and Montreal. Albums at this point were taking a long time and if truth be told, Cohen was finding the task of song writing more challenging than ever. So with a team of credited producers, a choir and an orchestra, The Future became a much more complex affair than the stripped, icy synthetic pop of I'm Your Man; and another sharp detour.

The opening number is the title track, which eases us in with warmth. There's a lively drum beat, some tidy organ and guitar interplay, while Cohen's voice is crustier than ever. But it's so up in

the mix that we can hear every single word that comes from his mouth, and also each breath; which of course is a good thing, when it's a man where every syllable is potentially a bit of gold.

"I guess the song was begun like most of my songs. Just kinda scraping the bottom of the barrel," Cohen told Bob Harris in 1993. "I never thought I stood in front of a buffet table and had a lot of things to write about, you know. It's just a kind of growing that you feel. A kind of itch that you can't scratch. Somehow you're just moving around in your mind, not in a very graceful way in a very awkward way, trying to centre yourself around something. At that time the Berlin Wall had just come down, when I wrote that, when I started to write it. And I don't know why but I had this... I had a hurt feeling about that, and a kind of gloomy feeling about that. We were rejoicing and of course one rejoiced and one saw the images of the wall coming down. And one thought that families would be reunited and country could continue on its own way. A split being healed is always some kind of attractive idea. But I don't know why I had a gloomy idea about it. People always said I have a gloomy idea about everything. I say that's true."

Although thematically it may be gloomy, there's a bounce to the music that we had never heard in a Leonard Cohen song before it. The idea of this kind of arrangement on a Cohen LP way back in the Songs From A Room era would have been totally unbelievable. By the 1990s however, Cohen's craft and approach had moved on so vastly, that the Cohen clichés of sorrow and misery don't really apply to his work from the early 90s onwards. Well, maybe just a little bit.

There's some really mixed material here, thematically, and some very interesting musical ideas too. On Waiting for the Miracle, the pace is slower and Leonard growls his lyrics over the mix like a movie narrator describing some form of longing of the soul. Be For Real is

another sweet ballad, this one a slow waltz with some heavenly backing vocals, sweet organ and guitar stabs. Again, Leonard's voice is up in the mix and there's a clarity in his words that instantly appeals.

Musically, Closing Time has aged a little now, with its whacky synthesizer sounds, but Cohen gives a nice vocal to it. It has a great chorus and, dare I say it, it's catchy as hell. There's also a lovely violin part on it too and some fantastic female backing vocals.

"I think Closing Time is just a sense that things as we know it are coming to an end," he said in 1993, "and that the flood is already here, the apocalypse has already occurred, like we don't need to wait for it. On the inner level, all the landmarks are down, and all the lights have been extinguished, and all the signs have been swept away. So we are in this period of closing time but all these songs, these sinister songs are married to, you know, hot little tracks."

Anthem is another standout Cohen track from the 90s. It has a slow, moody feel to it, with some wonderful guitar and string work, held in

place by a quiet beat and solid bass line. Melodically, there are some great chord changes and Cohen's voice is strong, but as low as can be on the register. In 1992 he spoke about its birth. "It's hard to do a commentary in special for this particular song because it took ten years to write. There's not a line in it that I couldn't defend. There's not a line in the album that I can't defend, but this song especially. I delayed its birth for so long because it wasn't right or appropriate or true or it was too easy or the ideas were too fast or too fuss, but the way it is now it deserves to be born. I've been playing this song for many years and I knew that I was on the track of a really good song. I knew it stood for something clear and strong in my own heart. And I despaired of ever getting it and I was playing it on Rebecca's synthesizer, and she said 'That's perfect just like that' And I said 'Really?' She said 'Yeah let's go down to the studio now!'"

Democracy is possibly the finest track on the record, starting with an all American drum roll before bringing in a growling bass and train-like synths. Leonard's voice is bright but subtly cynical, as he takes us through a typically imaginative and winding Cohen chord structure with those warm female backing vocals behind him at all times.

This is a very political album, especially for Cohen, who usually deals primarily with the complexities of feelings and the human condition. But although the songs on The Future are political, they are not fist thumping sing-alongs either, nor are they angry protestations against a system that doesn't work. Even his political work is more concerned with the individual amidst the problem than the problem itself and Cohen always ensures there is an emotional attachment between us and the song. We go along with his lyrical journeys; he asks questions, but never answers them, offering only views and possibilities. "I began the song about democracy in 1988 and I didn't get it out until 1992," Cohen said in 1992. "Well by the time I got it out, the song was co-

opted as a tool for the Democratic party. It was played on radio stations the week of the election. And it seemed to fit in with the president-elect's program. But hopefully my songs, which last as long as Volvos - that's 30 years. Hopefully my song will outlast this administration. It is a song where there's no inside and no outside. This is just the life of the democracy. It isn't imposed from above. It isn't connected to a Democratic victory or a Republican victory. It's coming through a hole in the wall, it's coming through a crack, it's coming imperial, mysterious in amorous array."

The Future may seem to have a more wide, world view type vibe to it because at the time Cohen lived in LA and could see the race-heated riots from his window, and couldn't help but oversee the raging fires and the violence. The concerns he had for mankind and its struggle to get along only made the album more rich in its lyrical content, involving the listener even closer into his poetry. Musically, thanks to a lot of help from his collaborators, it stands as an interesting and highly enjoyable addition to his discography.

It was a successful album across Europe and did very well in his native Canada too. When winning the Juno Award for Best Male Vocalist that year, Cohen couldn't ignore the irony of the man with the monotone voice bagging such a gong. "Only in Canada could somebody with a voice like mine win Vocalist of the Year." It had taken some time for Cohen to start getting the plaudits he deserved, but it was now happening, and that appreciation would only grow over the next two decades.

COHEN LIVE (1994)

Cohen Live is one of the finest live albums out there from one of the "big boys" of song writing, so to speak (even if Cohen once noted that he never quite felt like one of the serious contenders for the voice of a generation tag). His closest contemporary Bob Dylan released some great live documents in the 70s, but not that many after that era reached the same heights or captured the complex Dylan magic. While Cohen's own 1973 Live Songs is a personal favourite of mine, it's seen as something of a downer and is still no match for this record, a highly regarded example of Cohen in his late 80s and early 90s peak. The record consists of live recordings from both his 1988 I'm Your Man tour and the 1993 The Future world excursion, neither of which Cohen particularly enjoyed (especially the latter, which he found unpleasant). Both are good, but for me it's the 1993 material where Leonard and the band really seem to be on top form. There's a confidence in his voice and an ease for the listener to just lean back and take in every word he utters. The musicians are tasteful too in their embellishments and the mood is calm throughout.

Highlights include the opening rendition of Dance Me to the End of Love, a song which in my view is always captured more passionately in live recordings than it was on the still enjoyable Various Positions version. Bob Furgo's violin adds some fitting mystery to the mix, especially when you regard the song's dark subject matter, while Cohen's voice is crisp and crusty at the same time. Bird on the Wire is another one that seems to grow over the years in Cohen's live interpretations. While the LP version was intensely powerful, it was a song of dark dread and no hope. The musically rich version here however takes on a new strength of its own, almost like a gospel song and a strange optimism is evident in Cohen's voice, as if all is not lost.

Only five years on from its first recording on Various Positions, Hallelujah wasn't quite yet the anthem it is today, but it was on its way to that status for sure. Cohen slows it down to a twisted waltz, using some of the "lost" verses, and it works well, though not quite as effectively as the Lissauer produced original. But there are other versions of Cohen classics here that do enhance upon the originals. Like Dylan again, Cohen revisits and re-imagines his back catalogue in the live setting, changes words over the years as if to make them more relevant and meaningful to the current Cohen of the time. In that respect, the 1988 version of Who By Fire? is stunning in its bleak but strangely uplifting quality. Other early gems like One Of Us Cannot Be Wrong and Sisters of Mercy adapt themselves wonderfully to the middle aged Cohen approach.

The live set closes with a beautiful version of Suzanne, recorded in Vancouver in 1993, which gets a roar of applause. The voice may be lower, the manner restrained, and the key dropped way down, but it's a song that never loses its magnificence. In all, it's Cohen's first fully realised live album - although better ones were to follow - and just as fascinating musically as it is in its lyrical content.

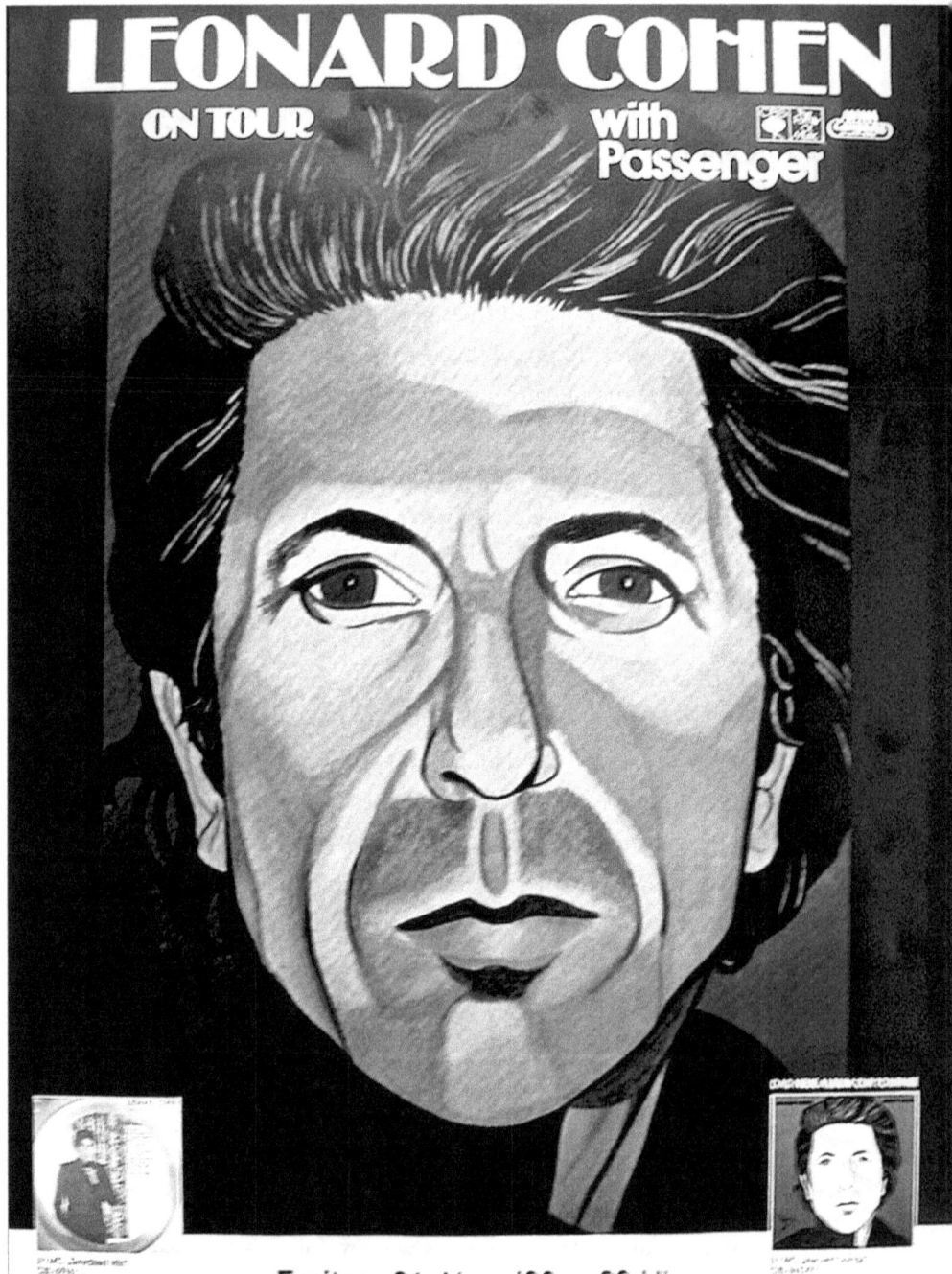

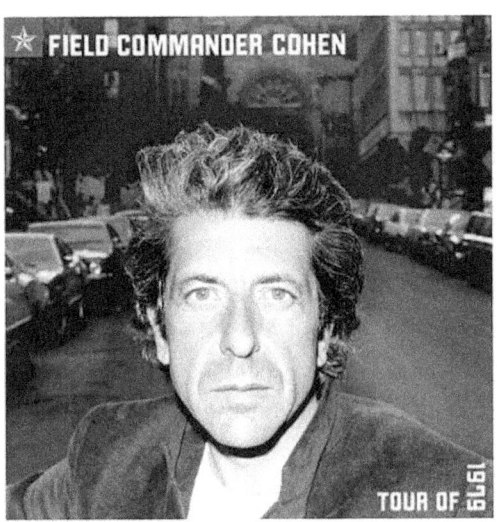

FIELD COMMANDER COHEN: TOUR OF 1979 (2001)

The latter part of the 1990s were a big time of change for Leonard. After The Future, he toured the album all over the world and released another poetry book, Stranger Music: Selected Poems and Songs. He also started a new record, but nothing came of it. Memorably, this era is dominated by Cohen's stint as a Rinzai Buddhist monk, and his lengthy retreat to the Zen Centre on Mt. Baldy in LA. He worked as assistant to his mentor, Kyozan Joshu Sasaki Roshi and from the documented evidence which exists, he seemed to be content with his new life away from the spotlight. On Roshi, his mentor and friend, he said "he's going to be an enemy to your self indulgence, to your laziness and a friend to your effort." He also told Stina Dabrowski that Roshi's job was to "cure the illusion that you're sick. He was successful in my case."

When Uncut Magazine interviewed him in 1997, they commented "at 63, Cohen is more charismatic than ever. Conditioned by up to 18 hours' meditation a day, at times he remains so impassively still that you want to check he is breathing. When he speaks, the voice is deep and resonant, sometimes reduced almost to a whisper, full of calm but animated at the same time. It is a serene performance that makes you want to ask what he's on and whether it's available on prescription. It is – but only in the natural pharmacy high up Mount Baldy, about two hours drive from downtown LA."

"In civilian life you close the door, switch on the television, crack open a beer and you're really alone," Cohen told them. "There's a saying in Zen that, like pebbles in a bag, the monks polish each other. You get very close when you're sitting with a group of people day after day meditating. You're not improvising in the way you have to in civilian life, so you relax into the regime. After a while, you're just thinking about your meal, your work and sleeping – so that is refreshing, because you don't have to speculate on matters that are really quite irrelevant and just produce anxiety. Over 2,000 years, most of the kinks have been ironed out, so it's an effective tool for removing unnecessary distractions and providing a space to live quietly. That's hard to find in the world."

In the midst of this, no new material, poetry, prose or music came forth, save for a compilation of his best known songs (which also included an outtake, Never Any Good). But Cohen didn't seem to mind. In his absence however, the cult of Cohen grew, and as the internet became more prevalent, websites dedicated to him began to appear. In the late 90s Cohen himself started sending bits of poetry and lyrics to the Leonard Cohen Files website, and it appeared that finally, after years out of the limelight, he was thinking of releasing and recording again. Of course the fans were thrilled.

Before any new product came forth though, the live album Field Commander Cohen: Tour of 1979 appeared, recordings taken from the very tour which Cohen himself claimed to be his personal favourite. The CD was taped at London's Hammersmith Odeon and Brighton's Dome Theatre. Backed up by the jazz outfit The Passenger, Cohen sounds in good voice throughout, backed of course by the wonderful vocals of Sharon Robinson and Jennifer Warnes.

It starts with a great version of Field Commander Cohen, complete with sci-fi keyboards and shuffling drums. Despite the lively, lighter opening, the album soon goes into the kind of melancholy area that Cohen doubters will roll their eyes at. But you cannot deny the beauty of this take on The Window, with its painful violin and heartbroken vocal performance. The Smokey Life, one of my favourite Leonard songs, sounds immaculate and flawless, more than equaling the album version. Grim tales of separation like The Gypsy's Wife sound almost empowered by the live arrangements; zooming bass, full keyboards and Spanish guitars adding spice to the song. New Skin... classic Lover Lover Lover sounds even more desperately lustful and longing than ever, with its steady groove, bendy guitar work, thumping bass and turbulent Cohen vocal. He goes way back to the first album for a spellbinding run through The Stranger Song too, which hadn't lost any of its haunting hypnotism over ten years on from its birth.

"In the absence of any new material, Field Commander Cohen is a welcome reminder not only of Leonard Cohen's genius as a songwriter but also of his abilities in concert," Pop Matters wrote at the time. "And as for his storied gloominess, this release bears subtle traces of the kind of knowing self-mockery and irony that have always been present in his work. After all, a man who can refer to himself as "grocer of despair" with a straight face, as Cohen does in the title track, clearly has a sense of humour."

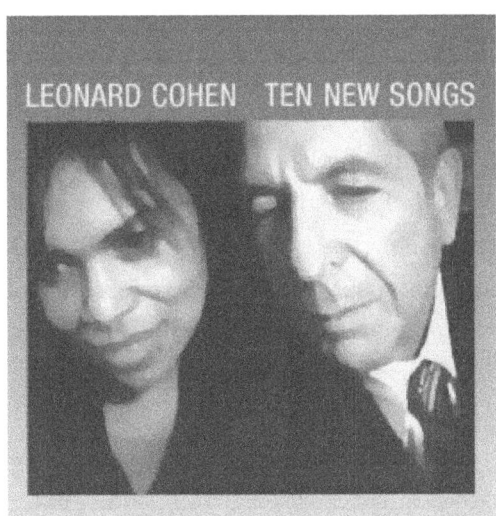

TEN NEW SONGS (2001)

Leonard once said that Recent Songs was the most perfect album title he had ever come up with. Twenty two years later he reappeared from obscurity with Ten New Songs, another good title, which was his first solo album in nearly a decade. For Leonard it was an important album and indeed an important time in his life as a whole. He told the Guardian that one day he awoke and realised he was finally at peace with himself, after, as they put it, "the past 50 years ploughing his way through drugs, drink, countless women and several religions in an attempt to find release from this 'backdrop' of self-doubt."

Throughout the interview, reflective of much of the press he did for the release of Ten New Songs, Cohen was more positive than ever and appeared to be in love with making music again. "There was just a certain sweetness to daily life that began asserting itself," he said. "I remember sitting in the corner of my kitchen, which has a window overlooking the street. I saw the sunlight that shines on the chrome

fenders of the cars, and thought, Gee, that's pretty. I said to myself, Wow, this must be like everybody feels. Life became not easier but simpler. The backdrop of self-analysis I had lived with disappeared. It's like that joke: when you're hitting your head against a brick wall, it feels good when it stops. When you stop thinking about yourself all the time, a certain sense of repose overtakes you. It happened to me by imperceptible degrees and I could not really believe it; I could not really claim it for some time. I thought there must be something wrong. It's like taking a drink of cold water when you are thirsty. Every taste bud on your tongue, every molecule in your body says thank you."

The new Cohen was a man who had tried everything and realised that none of it truly made him happy, whether it be drugs, drink, prescribed medication for his melancholia or being a monk. He seemed to come to the conclusion that not over thinking things would bring some form of contentment. He was, however, most interesting when he was discussing his new record. "There's a sense of relaxation in the tunes that comes through," he said of the album, "there's a kind of pulse, an invitation to get into it - a groove. A lot of people have danced to it. Erm, well, actually, one person. And she was, erm, an executive of Sony in France, and she's a trained dancer."

The process for recording Ten New Songs had begun in 1999 when Leonard moved into his old pad with his daughter. Sharon Robinson, his trusty backing vocalist, began collaborating on new material with him and pretty soon songs were coming to life. Of course, Robinson was a major collaborator on the album, more so than anyone had been before. Cohen wrote the lyrics and handed them over to her, so she could help come up with the music. It was recorded mostly in Robinson's garage which she had converted into a studio, and Cohen did his bits in a studio set up at his place.

The album opens with the much covered In My Secret Life, a crisply recorded ballad with a nice groove to it. The keyboards are smooth and seamless, the percussion holding it together and Cohen's voice, nine years on, deeper and more growly than ever. The backing vocals by Robinson add some welcome shade to the grumbling Leonard tones, and one cannot understate her influence on this record. The sound is refreshed, re-energised and a positive Cohen sounds at peace with himself. It ultimately makes for a more pleasant listening experience. Still, don't let the light, groovy sounds fool you; it's clear that Cohen is as soul searching as ever, he's just doing it in warmer musical surroundings.

A Thousand Kisses Deep is classic Cohen, a celebration of eroticism and passion atop a snaking rhythm, popping percussion and hypnotic keyboards. Cohen's voice is up front, "back on boogie street" with nowhere to hide in the sparse, clean mix. Again, Robinson adds understated harmonies distantly in the song, like a lost lover in the back of Leonard's mind. A beautiful piece of art and one of the finest from all his canon.

By the Rivers Dark is one of the best songs here, with its full but roomy musical arrangement making way for Cohen's voice and lyrics. Throughout, Robinson has ensured the music leaves enough space for the great man. For a man who supposedly can't sing, his voice sure does have presence. It "fills" the mix, very present without ever becoming remotely showy or even straying from its comfort zone. Somehow, despite all laws of supposed musicality, I would rather listen to Cohen whispering poetry than some glittered up poser performing vocal acrobatics up and down the scale.

Songs like Boogie Street are more about Robinson than Cohen and she displays her talent superbly on this soulful entry to the album. No wonder Cohen wanted her on the cover art with him. Musically, quite

curiously, it could almost have come off Madonna's 1992 Erotica album, suggesting that Ten New Songs did have that early nineties feel to it, which still makes it kind of soothing and nostalgic in some ways. Madonna herself explores eroticism, passion and love just as thoroughly as Cohen always has, only she does it a lot less subtly than Leonard. Still, one wonders what kind of collaboration Madonna and Cohen might have had back in the day; the well mannered, quiet ladies' man and the extroverted performer.

Reviewers were very happy to greet Cohen in his recording comeback. But Pitchfork were welcoming him back as a poet, not necessarily as a musician. "I should get one thing out of the way before this review gets too long," they wrote. "Leonard Cohen's charm, for me, lies mostly in his words and the way he says them. This is perhaps something he picked up from the poets, or maybe imbedded from his years as a writer, before he ever recorded a note. It's not that his music is easily dismissed, or even that his legacy isn't being closely guarded by dark, genius songwriters hidden somewhere in the corners between Bob Dylan, Nick Drake and probably anyone worth their ink

everywhere. Cohen's music is often the coolest part about what never immediately strikes me with his songs. It's just always seemed a little secondary to his words. He says, 'May the lights in the land of plenty shine on the truth some day.' And this is where I remember why I listen to him: Cohen says these words as if he heard them on top of a mountain. Maybe he heard them from some Zen master who doesn't have to live in our world, and must have realized their meaning while meditating, transcended from pain, but soaked in wisdom. But this is not where the words came from; Cohen said them, and he wrote them, and whether it's nice music or just amazing prose, I can only tell you what I heard."

Rolling Stone were happy with his return too, even if they did pull out all the clichés. "It's been nine years since we last heard from Leonard Cohen," they wrote, "an absence that's sent his rabid cult spiralling into poetically suave withdrawal. Thankfully, the other Man in Black is back from (somehow worse) depression, artistic inertia and monastic seclusion with Ten New Songs, a ghostly soundscape populated by the usual cavalcade of beautiful losers. Only now, with age, the bloody literary machine cuts even deeper; the voice, having succumbed to cigarettes and life, more achingly speaks that unspeakable desolation. Ten New Songs manages to sustain loss's fragile beauty like never before and might just be the Cohen's most exquisite ode yet to the midnight hour."

"Although the tones of these odes and meditations is mournful," Playboy observed, "at the age of 67 Cohen's pessimism about the human condition is tempered with reconciliation. He'll never be cheerful, but a Zen-like serenity pervades every song."

And so the poet carried on. As NME nicely put it, "life's a bitch and then you die, but in Cohen's case, nowhere near as early as he imagined."

DEAR HEATHER (2004)

Thankfully for his quietly obsessive fan base, Cohen didn't take nine more years until he released his next album. Only two years later in fact, Dear Heather arrived, with thirteen new songs for us all to devour. Three of these were left overs from his work with Sharon Robinson on Ten New Songs, while the rest were new songs recorded with himself, the great Anjani Thomas (his close collaborator and girlfriend), Leanne Ungar and Henry Lewy on production duties. While Ten New Songs had been safe territory for Leonard and much of the music had been taken on by Robinson, he had more confidence on Dear Heather and thus he stretched himself a little further.

Of course, those who thought Leonard was suddenly upping his work load at the age of 70 couldn't have been more wrong. The truth is that he worked all the time anyway; he just didn't release all of the material he created. By 2004 however, Cohen seemed to be putting more out there. Only two years after Dear Heather appeared, Book of Longing emerged, a collection of poetry and sketches Cohen had done while on Mt Baldy. For now though, Cohenites were more than happy to feast upon his latest sonic release.

The first song is Go No More A Roving, an adaptation of Byron's poem done in typically restrained Cohen fashion. Robinson is very evident on this one, adding her unique voice and musical ideas to accompany Cohen's wonderful grasp of the poetry. Because Of has Cohen speaking over the music, reciting one of the memorable poems that pops up in Book of Longing, while the music beneath his voice is quite peculiar, jaunty and experimental in its own curious way. For me one of the finest songs is On That Day, Cohen's haunting and beautiful reaction to the atrocities of 9/11. While we all knew that Cohen was the man to be inspired in song by that fateful day, who knew it would be such an oddity with a Jew's harp solo in it? Musically and lyrically it's up there with his best work on The Future and Ten New Songs, by far one of the most effective tracks on this set.

The Letters is another stand out, a sublime Cohen/Robinson duet with a tragic and romantic vibe to it. The title track is another odd little piece, with toy organ and Casio drum beat beneath the almost robotic recitation. Elsewhere, Cohen reads his poetry on the likes of To A Teacher, while Villanelle for Our Time is a poem by FR Scott which Leonard reads aloud for us. The Faith is a startling duet between Cohen and Anjani, and a perfect example of the way their voices blend together so well. But then, Dear Heather is full of all kinds of surprises, and it's interesting and admirable for a man of 70 to experiment so fearlessly with poetry and music. Of course, only Leonard Cohen could be the man for a job like this. It may sound to some like the kind of CD they put on in the background in coffee shops, but it's still a worthy addition to his discography.

Leonard didn't do a lot of press for it and kind of let the album sell itself. Reviews were OK, but not as strong as they had been for Ten New Songs. I suppose I can see why some critics found it hard to get into, as its a peculiar album, and more of a music and poetry

experience than a regular CD of songs. Also, voice wise, Cohen was no longer singing at all by now - that just had to be accepted if you were still along for the ride - and he relied on backing singers to add the melody. The words are stronger than ever here though, thanks to the wisdom of age, and the music remains fresh, inventive, often very imaginative and unexpected. There's none of the precise, neatly arranged musicality of the Lissauer work, and it also lacks the haunting acoustic sound of his earliest records. Dear Heather kind of exists on a separate plain. Most reviewers though just couldn't accept it as its own entity.

"Dear Heather demonstrates that age brings with it its own problems," wrote the Guardian in a harsh review that seemed to blow way out of proportion. "Not least the fact that Cohen cannot really sing any more. Ravaged by cigarettes, his voice has almost vanished into a husking whisper. Here, the arrangements are frequently ghastly: rhythms that sound suspiciously like factory settings on a cheap synthesizer, keyboard noises that sound suspiciously like factory settings on a cheap synthesizer, the oily sax imported from a hotel lobby muzak tape."

Others saw it as something very special, like Pitchfork, who raved about it on their website; "Dear Heather is a gorgeous, quietly poignant rendering of autumnality. Only Cohen could have pulled it off. And unlike Ten New Songs, I can't stop listening to it, which seems the ultimate justification for praise. Above all else, it's an honest document of this stage of Cohen's life, and it therefore honours his lifelong commitment to unflinching self-scrutiny."

Anyone who wasn't familiar with Cohen's music before this album may have been surprised by the variety of sounds and its soothing atmosphere. As a musician, I am floored by it every time I hear it. It's a kooky gem, going by its own offbeat set of rules.

ANJANI THOMAS INTERVIEW

Anjani is very important in the career of Leonard Cohen. She was performing in jazz clubs before being spotted by John Lissauer and recruited as a backing singer on the Various Positions album, providing memorable back up on Cohen's anthemic Hallelujah. She remained close with Leonard here on after, personally and creatively, singing on a number of his finest records. In 2004, they collaborated on Cohen's Dear Heather, before creating her own "solo" album Blue Alert, combining Anjani's music with Cohen's poetry.

When putting music and melodies to Leonard's poetry, as you did on Blue Alert, do you ever feel intimidated at all, to do those lyrics justice? Or do you see it solely as a challenge and also as a privileged thing to be able to do?

Fortunately, I never felt intimidated, only challenged. We inspired each other to give our best effort to each song, and both of us ultimately agreed when something felt incomplete or out of alignment.

Out of the female vocalists Leonard has sung with over the years, he seems to share a very special musical bond with you, especially in the sound of your two voices together. Was this connection always present, kind of naturally, or do you think it grew over time? And do you think some voices just instantly gel?

The connection was always there, and recording a stack of harmonies has always been an easy, enjoyable process for me. Leonard appreciated how quickly I could colour in the spots where he wanted to hear a feminine counterpart to his voice. I think all of the women who have sung with Leonard have exceptional voices and musicality, plus the ability to blend in seamlessly with him.

Blue Alert has some wonderful material on it. Do you ever listen back to it and if so, what do you think of it now?

Every now and then someone will have it on a playlist at a restaurant or yoga class, which always takes me by sweet surprise because I generally don't play my own tracks. So far, I find Blue Alert as mesmerizing and relevant now as it was when we recorded it. I could listen to Half The Perfect World every day and not tire of it, which, for me, is saying a lot.

When you sing with Leonard, especially live, people really respond to it. How do you figure out a vocal part to fit alongside Leonard? Is it always a case of singing a scale or 2 higher or does it often take more thought than that?

He seemed to prefer the balance of harmony in 3rds, so I generally stayed with that except for a tune like Jazz Police (from I'm Your Man).

One of my personal favourite duets of you and Leonard together is The Faith, from Dear Heather. I wondered how the process was for putting a recording like that together?

The way Dear Heather came about was such a mystery. There was no overall theme for the project. Because we recorded it at Leonard's house, he wasn't pressured by a budget, which is a luxurious and freeing position to be in when creating music. There is a voluptuous morning glory vine on his backyard fence that he wanted to write an ode to. He spoke about it so intently and often, going on and on about how wonderful my background vocals were going to be... that I started to get a bit nervous because I had no idea what I could invent to live up to his high praise. But you can tell we had fun and it does have an odd beauty to it. The Faith was a blank vocal track he'd had for years and couldn't figure out what to do with it until then. It really is a gorgeous melody that sails right along.

Do you have a favourite from Dear Heather?

My favourite is Undertow, which I've spoken about before, because it's the track where I really uncovered the focus and intensity of my solo voice. It had eluded me until then, which is the downfall of many a singer who can easily sound like other good singers doing any kind of genre. But to have your own truly distinct sound is a gift, and one the that came to me through working with Leonard.

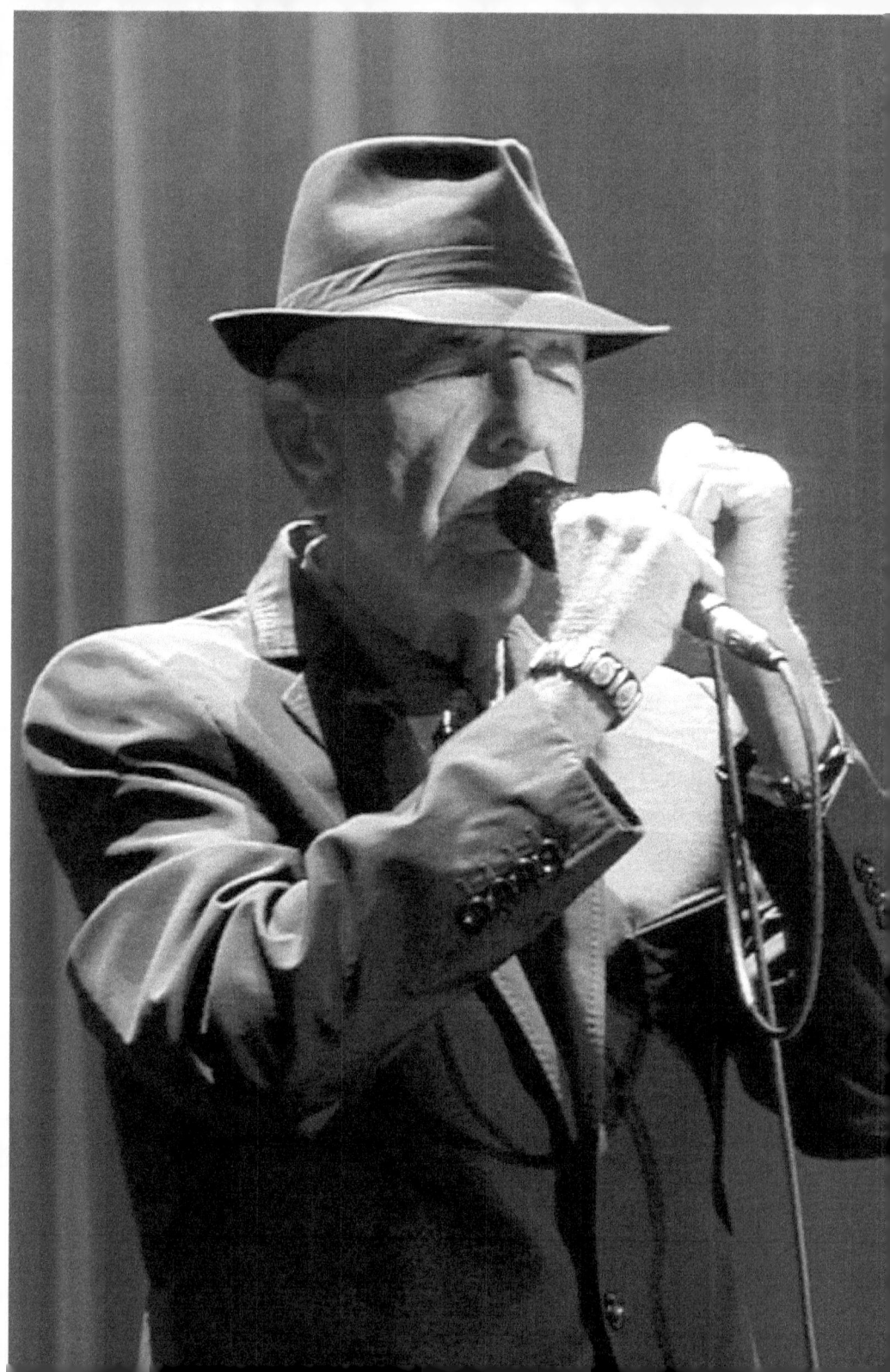

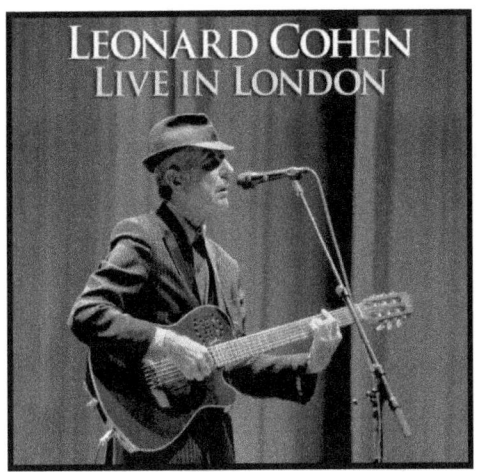

LIVE IN LONDON (2009)

In some ways, there is a mental conflict when considering Leonard Cohen's emergence into a globe trotting troubadour, selling out arena sized venues in every country in the world, playing to adoring audiences and getting the best live reviews of his career. On the one hand, it was great to see Leonard out there in his mid seventies, on a "never ending tour" of sorts akin to Bob Dylan (although this one did actually end), playing the old favourites and defying all odds by packing them in night after night. On the other hand, you have to think of the reasons behind his large scale tour. Cohen's manager Kelly Lynch, a family friend and confidant, had turned out to be less than trust worthy after all. In fact, she had totally ripped Leonard off and cleaned him out financially. It had started when he was up on Mt Baldy, selling his publishing rights and slowly draining his accounts. Leonard had to figure out a way to rebuild that money, all the while still being in the midst of legal battles. After all those years of hard work, he was forced to go back on the road again.

The positive side of all this was that Cohen went out and played what many view as the best gigs of his career, with arguably the finest backing band he'd ever had. The tour began in 2008, with Cohen planning to get out there and earn some bread for his retirement. This live document was recorded in July 2008 at London's huge O2 Arena, coming out as both a CD and DVD. In short, it's a stunning example of Cohen and company at their peak.

What strikes most is how Cohen makes his vocal limitations work and rarely do you stop and really consider his low, often one note voice. Somehow, mostly thanks to pitching the songs lower and punctuating them richly with fine instrumentation, it all falls into place. Cohen also defies all the clichés of him being the wretched doomy minstrel of depression and comes across as a subtly witty stand up comic for all the ages, especially the elderly. The quip "I was just a sixty year old kid with a crazy dream" immediately springs to mind.

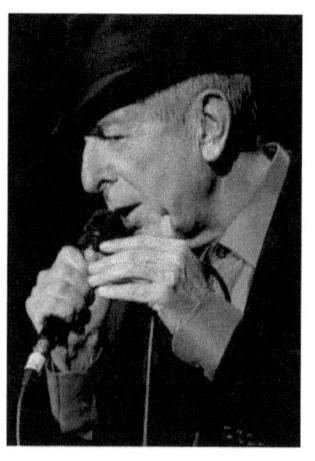

It starts with a typically spellbinding version of Dance Me to the End of Love, the finest way to start a Leonard Cohen live album. Though he's backed up by a superb band, including the ever reliable Sharon Robinson, bassist and musical director Roscoe Beck (a regular Cohen collaborator) and the Webb Sisters (Charley and Hattie, the backing vocalists perfectly suited to Cohen's material), Leonard himself remains the central focal point throughout.

It's very much a greatest hits and "best of Cohen" kind of affair, and like he did throughout the tour, he goes back to the early material; Bird on the Wire is given optimistic soul, Who By Fire is romantic as

usual, while the great Cohen anthem Suzanne may be lower than ever, but it hasn't lost any of its magic. Witty moments arrive on Tower of Song, with Cohen introducing his nifty Casio ("I don't want anyone to get alarmed. You've probably never seen one of these before.") before delivering what I believe to be one of his finest set of lyrics. He reclaims his masterpiece with a pure and blessed run through Hallelujah, by now the classic we all know and love. Others may have done it a decent service, but Cohen blows them all away here with this fine rendition. His voice has never sounded so assured and hopeful, delivering the words he slaved over in a manner only a true poet could.

 Cohen had never been a fan of touring, but now in his mid seventies he was clearly enjoying it. "I learned that it's hard to teach an old dog new tricks," he told Jian Ghomeshi in 2009. "I've been grateful that it's going well. You can't ever guarantee that it's going to continue doing well, because there's a component that you really don't command. Some sort of grace, some sort of luck. It's hard to put your finger on it - you don't really want to put your finger on it. But there is that mysterious component that makes for a memorable evening. You never really know whether you're going to be able to be the person you want to be or that the audience is going to be hospitable to the person that they perceive. So there's so many unknowns and so many mysteries connected - even when you've brought the show to a certain degree of excellence."

 Fans and critics were ecstatic about Cohen's "comeback" and return to the stage. The BBC put it nicely in their review of the live album, writing "It's enough to make you impatient to reach your 70s. Let's hope a few of us can remain this warm, good-humoured and still in love with life when we do." Amen to that...

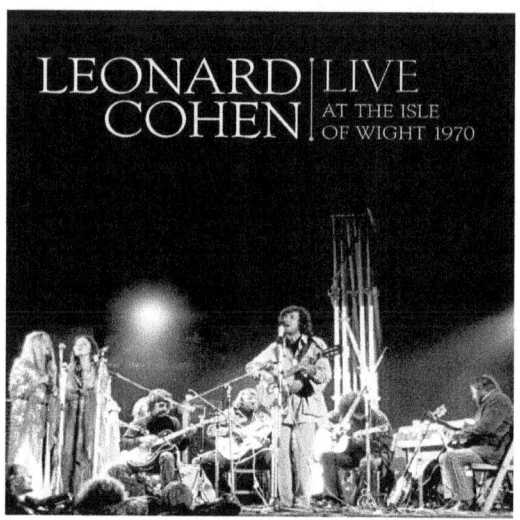

ISLE OF WIGHT 1970 (2009)

The next Leonard Cohen release, later that same year, was a CD and DVD document of his legendary performance at the 1970 Isle of Wight festival. It was a violent, turbulent event that started peacefully and ended up in chaos. Artists were booed, fights and fires broke out and there was a general feeling of hysteria everywhere. Woodstock was *so* last year, the spirited 1960s were long dead and in this new decade the bright, naive hopeful views of the previous decade had been replaced by paranoia, fear and confusion. So began the 1970s, and the fiery atmosphere at the Isle of Wight almost single-handedly sums up the complete cultural turnaround of that year. However, one artist who walked on to the stage in rags at the festival seemed to bring everyone together. Everything seemed to go quiet and peaceful for a short time. The reason? Leonard Cohen and his band, The Army, were playing.

The fact that Cohen followed Jimi Hendrix's phenomenal set makes his warm reception all the more amazing. He played in the early hours

of the 31st of August before 600,000 people. Filmmaker Murray Lerner was worried about Cohen's safety, especially after Kris Kristofferson had been booed earlier that day. "As I watched him walk out there I thought this is going to be a disaster," Lerner recalled. "Because the mood was still very mixed. There was definitely a sense of bad feeling, though there was also a sense of people being tired and not so aggressive as earlier. But Cohen was essentially acoustic, just as Kristofferson was, and I thought the crowd would be expecting a bigger high in terms of the sound of the music."

Of course, Lerner and anyone else need not have worried. An unshaven Cohen, who looked half asleep in his pajama (he'd just had a nap in his trailer), came on to the stage with his peaceful gathering of minstrels - including the heavenly backing singers Corlynn Hanney, Donna Washburn and Susan Mussmanno, plus his own producer Bob Johnston on various instruments and Ron Cornelius on guitar - and calmed everyone down. From the moment he stands on to the stage, there is an ease which spreads throughout the fields that is really quite breathtaking. He effortlessly commands the crowd with carefully, quietly spoken words (a story about going to the circus with his father), before gently going into the first song, Bird on the Wire. Cohen is certainly off key and sounds knackered out throughout the song, but somehow he makes all those people stop and pay attention. It's a credit to the great man's quiet power and charisma.

It's an absolutely magical set and even though Cohen's voice often goes way off, there are fantastic versions of So Long Marianne, Diamonds in the Mine and You Know Who I Am. In fact it's all so rich that picking out highlights is futile. Lean back, put the headphones on and float away. You can almost meditate to this whole CD, as Cohen and his delicate Army take you through his gloomy but comforting early catalogue.

SONGS FROM THE ROAD (2010)

Another Leonard Cohen live album was next in the release schedule, this one taken from highlights of concerts in 2008 and 2009; snippets of Tel Aviv, Glasgow, London, various European cities and Canada were included, and at every show Leonard is clearly having the time of his life. It was a little over a year after the release of Live in London, but fans didn't seem to mind. This was a monumental tour and the more well recorded artefacts that exist of it the better.

The track listing for one is really interesting and it's great to hear some of these tunes preserved on a more up to date live album. Lover Lover Lover for instance may have lost some of its sense of turmoil and gutsy intensity, but Leonard's voice does well to enhance upon the original. It helps of course that he's supported by a superb band and those backing vocalists, but he fits himself into the jaunty groove with a sense of ease. Songs like That Don't Make It Junk from Ten

New Songs don't quite get the crowd roaring in recognition, but I find these lesser known numbers come across very well in concert.

Elsewhere, there's the ultimate doom ballad, his almighty Avalanche from Songs of Love and Hate. It sounds fantastic, frightening and full of despair; in a word, it's fabulous. Cohen utters the words knowingly and plucks his guitar with arachnid fingers overlapping each other spookily. Famous Blue Raincoat also works wonderfully in this new arrangement, while no Leonard Cohen live album would be complete without Hallelujah (even though that weird superhero sex scene in Watchmen has almost ruined it for me... well, not quite).

In all, Songs from the Road is very good, but it isn't quite as up there with Live in London. In comparison to the double CD onslaught of its earlier counterpart, this one feels more like an extra add on. Perhaps it would have been better to put out a triple album in the first place (as he would do later), or get it down to two discs and compile all the definitive tracks from the tour. That said, this is still a very welcome release. We'll be glad of these albums in the future.

"I suppose there are some Cohen fans who cringe at the smoothness of his live sound," Pop Matters considered, "its instrumental edges sanded down so that it's all on Cohen's shoulders to summon forth the shadows, but that seems a little silly at this point. Cohen hasn't trafficked in brooding folk in at least twenty years (brooding pop, sure...). If anything, Cohen's current sound can be seen as a recognition of the openheartedness and humour that's often been overshadowed by his darker material. With Songs from the Road—which, along with Live in London, comes pretty close to capturing all the Cohen catalogue you might be craving—we continue to get a fuller portrait of one of our best and more enigmatic songwriters."

OLD IDEAS (2012)

"It was the old ideas, old – you might even say unresolved – ideas that are wracking around in my brain, and the brain of the culture."

Who'd have thought it, eh? The same man who spent decades being marginalised by the music media, who had to endure the endless jokes about him being the most depressing singer in the world, who didn't even get into the Billboard Top 100, was now Number 1 all over the world, becoming the oldest chart topper of all time and getting the best reviews of his career. He even got into the top five in the US! Cohen had become one of the major live attractions of recent times and his records were selling more than ever before. Amazing really.

Cohen finished his large tour and returned home to start work on a new album. The gigs had inspired him to get back to writing new music, and in very little time, at least in relation to his past works, he had a full album of material. Put down in his home set up, he was

once again aided by Sharon Robinson and engineer Leanne Ungar. It was business as usual for Cohen on the lyrical front, the troubles of love, relationships and the carnal act being the order of the day. Then again, love and sex are not just Leonard's big concern; all of us are obsessed, hence why we can all relate to his lyrics on such a wide scale. Age hadn't weakened his fascinations one bit.

Cohen did a number of the tracks with legendary producer Patrick Leonard, who had famously worked with Madonna, and whom Cohen found interesting and talented. Although you wouldn't think to put their names together, the results of their collaboration are very fruitful to say the least. They did a number of tracks together, the finest of which is the album's opening song, Going Home, clearly one of Leonard's greatest songs in years.

"Well, we came off the tour and we didn't do very much for a little while," Cohen told Rolling Stone upon the release of Old Ideas. "Then I bumped into Pat Leonard. I was listening to my son's record, which I thought was very beautiful, and Pat had done some lovely work on that, especially some string parts that he'd written. And I thought I'd ask him to do some string parts on some other songs of mine. That didn't work out, but we started to write together, and then it went kind of swiftly. We recorded it in my backyard. I have a little studio over my garage – Pro Tools. So we were in very small studios, with Pro Tools. But we ran it through analogue, which is where you get the warm sound. It didn't take much more than a year to record, working off and on."

Amen is a strong one too, with his lived-in, slept-in voice croaking like a man on 200 cigarettes a day. Over the jazzy subtlety, his characterful tone reflects the adventures of a man who has lived a life, been there and done that, with more than a few stories to tell. Another collaboration with Patrick Leonard, Show Me the Place, is a

gorgeous song, with Patrick's melodious piano colouring the landscape and leading Cohen's crinkly voice towards its sweet tune quite wonderfully.

The acoustic guitar is a very welcome sound on Crazy to Love You, possibly one of his finest songs in decades (in truth it could have fit nicely on New Skin). His voice is aged, but it works brilliantly, and infinitely more than it would have had it been sung by a young man. There's a wisdom to the music that is hard to define. It's an old man with a young man's problems, issues and hang ups. Refusing to retreat to the retirement home, Cohen is ageless, immortal and as relevant as ever. When grooving us out to the sounds of Different Sides, you conclude that this is a fully realised, musically adventurous, lyrically rich and "complete" album with a view, place and sound all of its own.

Decades on from his first classic LP, Cohen made a modern masterpiece, much to the surprise of his biggest critics. Compared to his previous studio album, 2004's misunderstood Dear Heather, Old Ideas was accepted as a triumph. There's genuine life to the numbers and coming from a man nearing 80 years old, that makes it all the more unbelievable. There's no "old man blues" here. Cohen is a man at the top of his game; the aging poet soldering on, pondering the complexities of the soul, his age irrelevant now, but still worth acknowledging as a testament to his longevity.

"Cohen's imagery throughout is elegant, thoughtful and occasionally startling," wrote the Telegraph in their glowing 5 star review. "It is, in short, and as we might have expected, a work of genius. Sometimes the old ideas are the best."

As a long time Cohen fan, there's something truly satisfying about seeing him get such credit and appreciation these days. A decade ago I was defending my fondness for Leonard Cohen. Now I'm just another chump singing his praises.

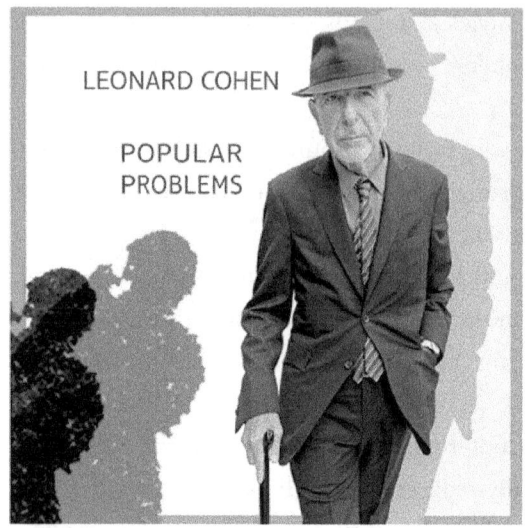

POPULAR PROBLEMS (2014)

Popular Problems, in many ways, is like act 2 of the Old Ideas ethic, a thematic continuation of its predecessor, but also a step forward towards somewhere else. Again, Cohen decided to pair up with the extraordinarily talented Patrick Leonard and the results were exciting, fresh and infinitely interesting. Patrick took on co-production and keyboards, while Cohen stuck to the lyrics and vocals. Backing vocals were provided by Donna De Lory, Dana Glover and Charlean Carmon, giving the album an often more soul orientated groove. Indeed, Cohen's music now had more life to it than ever before. At only 35 minutes, it was a return to the short vinyl format that was the order of the day when Cohen first started recording. For me, these nine tracks, in a little over a half hour, are just perfect. It's a brief stay, but one that warrants repeated visits time and time again.

Upon completion of the record, Cohen spoke to Rolling Stone about it. "It's the done-ness of it that I really like. It nourishes me. Some guys

don't know how to open a door. It's very nice to go into your backyard and climb up into your studio. We had some good mics there, and both Pat and I had our keyboards, so we were able to flesh out these songs. I never had an approach. I was always like a bear in a honey tree, just trying to get something without getting stung to death."

"We tried a few songs together and they came together rather quick," Cohen said of working with Patrick again at a London press conference. "Pat supplied the music. It's a mysterious process. I don't really know much about it. And neither does Pat. And neither do you. But we're very happy with it. We're working on a new record. We've got half of it finished. So perhaps we'll meet again. The next record will be called Unpopular Solutions."

"We'd accumulate several songs, and Leonard would learn to sing them," Patrick Leonard told Sound On Sound, "and I then went over to his house where we'd sit for an afternoon. He'd do 10 takes of each song, and I'd take them back home, where I would comp the vocals for each song."

Slow is a brilliant opener of controlled mature energy, with Cohen growling like an old blues master, backed up by the trio of backing vocalists quite wonderfully. And just what does Lenny like slow? Just what does he want to make last that little bit longer? We'll leave that to our filthy imaginations. Of course, any other 80 year old bloke singing about sex would seem like a dirty old bugger; not our Leonard, oh no. He turns womanising and our unstoppable quest for sensual satisfaction into a poetic art form that rivals the great poets in history. Still, Leonard continues to change the rule book. It was the first track Patrick and Cohen wrote for the LP and it's a perfect start for what follows.

Almost Like the Blues is a classy little number, with a funky bass line, haunting piano part, foreboding keyboards, a reliable, comforting

blues structure and finally a battered, beaten, down-but-not-out vocal by Cohen. Samson in New Orleans is suitably understated, with sparse music making way for Cohen's wonderful vocal effort.

A Street is an extremely delicious one, and it could have come right off the Future album, with its perky keyboards, cool drums and full vocal. "When I say 'the party's over but I've landed on my feet / I'm standing on this corner where there used to be a street', I think that's probably the theme of the whole album," Cohen said when speaking of the song, using it as the theme tune for the whole record. "Yeah, the scene is blown up, but you just can't keep lamenting the fact. There is another position. You have to stand in that place where there used to be a street and conduct yourself as if there still is a street."

Nevermind is one of the strongest cuts, with a meaty electro back drop beneath Cohen's spoken grumble. "There comes a point, I think, as you get a little older, you feel that nothing represents you," Cohen said of the track. "You can see the value of many positions, even positions that are in savage conflict with one another. You can locate components on both sides that resonate within you." A reference to the conflicts in the Middle East and across the world perhaps?

Even though Popular Problems clearly concerns personal issues again (not ones just for Leonard, but for all of us, the everyman and woman), there are definitely some wider issues on display. Cohen was asked by the Telegraph if this was a political album at all. He replied "I've tried over the years to define a political position that no one can actually decipher. Of course it reflects the world that we live in. One picks up these things from the atmosphere."

However political it is, in my view, Popular Problems is an even bigger improvement on the music he committed to tape (well, Pro Tools) on Old Ideas. The music has more punch (more down to Patrick Leonard's expertise than anything), the lyrics are even more witty, memorable and endlessly quotable, and the melodies are infinitely richer too. It feels more sturdy, defiant and confident. And it needs to be added, it's a lot more funny too.

"The very first gag on this fine record is, of course, the album's title itself, a little oxymoronic koan," the Guardian noted. "How can a problem (bad) be popular (good)? Really, though, the stuff of Popular Problems is the stuff we all struggle with: the problems of the people. The final laugh comes at the end. 'You got me singing,' harrumphs Cohen, not actually singing, 'even though it all looks grim.' And he's 'singing that Hallelujah hymn', having come full circle from the bedroom to God, while mischievously name-checking his most famous song."

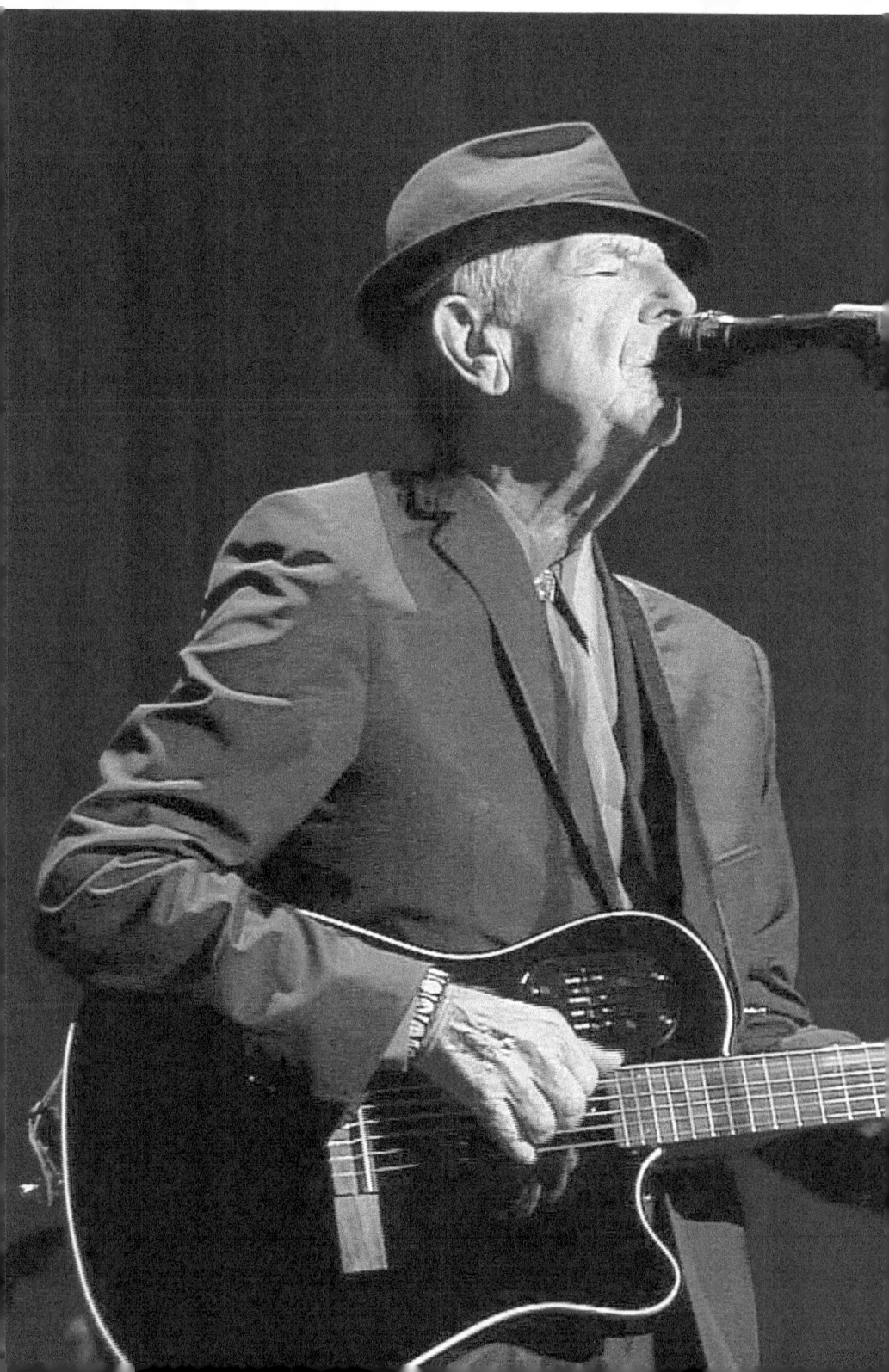

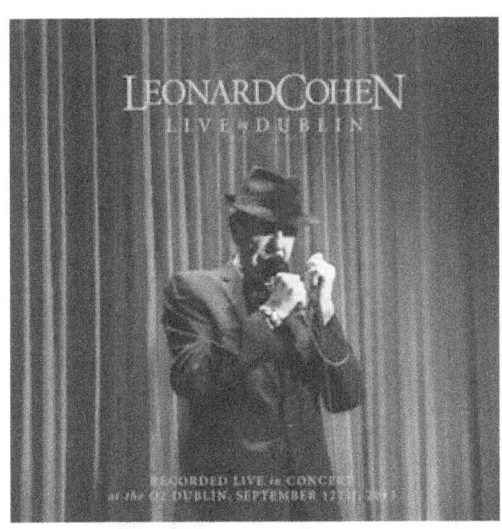

LIVE IN DUBLIN (2014)

Another live album from Cohen's recent resurgence as an arena icon, this one recorded in Dublin in September 2013 and spread over three whole CDs. It seems to be an extravagant idea - three hours of live Cohen - but it's a deserved amount of time for such a catalogue of songs. While it lacks some of the freshness and spontaneity of the earlier Live in London release, this is still a solid live album that any Cohen fan will want to have (you can never have too much Leonard Cohen). It helps that he covers his more recent songs, and some of his more obscure pieces, as well as the old classics too of course.

The performances are nice, especially the opening Dance Me to the End of Love which has a bit more energy in it than usual. The Future is fantastic, finally taking its place as a classic in Cohen's discography. Inevitably, the standards get their outing; no Cohen concert would be complete without a bluesy, passionate take of Bird on the Wire. Everybody Knows and Anthem stand proudly beside classic fare like

Lover Lover Lover, which continues to grow as the years go by, with new melodies and subtle touches appearing, not to mention the flare that Cohen gives it vocally.

Tower of Song, one of his "towering" trademark pieces, is very welcome, and it's become something of a running joke when he gets the keyboard out, warning the crowd before hand in case they get too alarmed by it. Suzanne is particularly strong on this set too, while songs like Chelsea Hotel should sound odd coming from an elderly man, but they just don't. Still, all these years on, he makes these songs remain relevant to an 80 year old, despite the fact they were written by a man in his thirties and forties.

I'm Your Man era gem First We Take Manhattan is another one that's aged nicely and still stands up (perhaps more so during these days of terrifying modern terrorism), with its added guitar parts and a clap along crowd, who are clearly loving the whole spectacle.

Live in Dublin is a genuinely enjoyable and richly textured live set, and it's one that's more worth hearing for the lesser known and newer tracks rather than for the anthems; the oldies are still good of course, but it's a real thrill hearing the less likely material.

"Live in Dublin is only the latest live album since Cohen returned to the road in 2008," wrote Pitchfork in their fair review. "Having been swindled out of his savings by a manager. He previously released the closely similar CD/DVD collection Live in London, documenting a show from that first year of touring. And there was 2010's Songs From the Road, compiling a somewhat different set of songs from various 2008-2009 performances. Whether Field Commander Cohen: Tour of 1979, Cohen Live (drawing from 1988 and 1993 tours), or Live at the Isle of Wight 1970, live material from the supposedly not-so-golden-voiced songwriting giant is hardly lacking. There's still plenty to recommend on Live in Dublin - in all earnestness, at that."

Uncut were all praise though, writing "He may be a lazy bastard living in a suit, as acknowledged in another well-received line from Going Home, but as he sails into his eighties, Leonard Cohen still puts in a serious shift: a generous 30 songs, spread over three hours, drawn from all but a few corners of his career. And while several of his musicians play seated, Cohen's on his feet the entire time, save for the moments where he drops to his knees in supplication, beseeching the audience, or urging a player to greater heights of artistry. He runs on stage, clutches the mic like an alkie's bottle, supping its emotional draught through opener Dance Me to the End Of Love, and even manages to skip gaily off the stage at the end of each set, as if confirming that the older one gets, the more one reverts to childhood."

CAN'T FORGET: A SOUVENIR OF THE GRAND TOUR (2015)

At the time of writing, the latest Leonard Cohen release is another live document of the 2012 to 2013 tour dates (yet another live album is due for release soon; clearly Cohen regards these recent concerts very highly). Recorded in various countries on Cohen's globe trotting jaunt, such as Denmark, Canada and Australia at some of finest venues in the world, the CD is again notable for some of its quirkier choices. For me the highlight is the opening Denver soundcheck take of Field Commander Cohen, an old favourite which is simply a joy to hear.

As good as this set is though, you can't help but wonder why a lot of fans would really want another live album, which as Uncut put it "seems to be stretching the loyalty even of Cohen's army of devoted fans." The truth is though, it's well worth having for its many strong moments, like I Can't Forget and a startlingly good Joan of Arc. Still, anyone who is just a casual fan who forked out for the triple Dublin set is unlikely to part with more cash for this - unless you were at one of the gigs of course and wanted something to remind you of it.

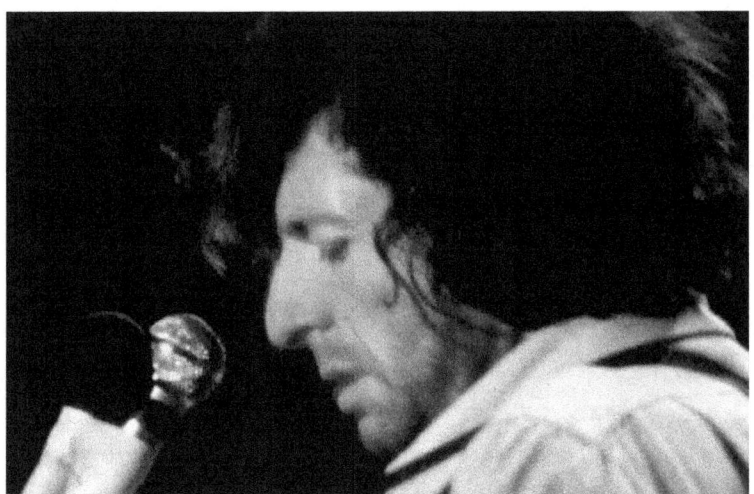

POSTSCRIPT

"I never give that much thought. Some people care about their work lasting forever – I have little interest in it. You probably know that great story about Bob Hope. His wife came to him and said, 'There's two plots available at Forest Lawn. One looks at some beautiful cypress trees, one looks over the valley. Which do you think you'd prefer?' He said, 'Surprise me.' That's the way I feel about posterity and how I'm remembered. Surprise me."

So were Leonard Cohen's words upon being asked by Rolling Stone how he'd like to be remembered. There is a stark finality in their question, the kind of full-stop, end-of-days gloominess that would send most folk into a panic of dread. Not Leonard. Even though he's into his 80s now, he's still creating art, still making his way into his home studio, still writing, still working, and presumably still putting on a suit every morning. He has a gentle lust for life that is infectious and as one writer noted, makes you look forward to your own old age, considering of course you are as blessed as Cohen is.

There's an irony in the fact that Cohen, the great deliverer of despair, has outlived many of the rock and folk stars who emerged in the same era as he did - it's more remarkable considering he was a generation older than them too. The wild Janis Joplin (with whom he had an encounter), the even wilder Jim Morrison, the fiery performer Jimi Hendrix and the rest of their ilk were gone in a flash. These people, who they say lived for the moment, never even made it past their twenties. Did they have a lust for life, or did they know they were destined to burn out fast? Either way, it's irrelevant when considering that Cohen, that dreary serenader for the damned, the man who made records so grim he said they should have given out free razor blades with them, is still making relevant music, music full of joy and a celebration of life itself. Consider that for a moment. It's a joke that won't be lost on Leonard himself.

Cohen's discography is a rich and surprisingly varied one, taking in world music, folk, acoustic, the indescribable Phil Spector sound, doom folk, the confessional, recited poetry, euro pop, synth, blues, jazz and any other genre you could hope to think of... save heavy metal of course; but who knows, maybe that's next! All of it is tied together by Cohen's distinct lyrics and calmly comforting voice, a voice as familiar to us as Bob Dylan's nasally whine, Lou Reed's laid back drawl, Neil Young's primitive wail and all the other icons who've made their immovable dent on music history. The exciting thing for me, and millions of others of course, is that Cohen and some of his contemporaries are still around, right there on the cutting edge, creating fresh new work that people can relate to and enjoy all these years on. Cohen's tale is the most unlikely of all though; the man who supposedly can't sing, who rarely charted in the US and stayed on the fringes of the mainstream, is now one of the biggest stadium draws in the world. Maybe he does have a golden voice...

ACKNOWLEDGEMENTS AND REFERENCES

I want to thank the people I interviewed for this book; Art Munson, Anjani Thomas, John Miller, Tony Palmer, Emily Bindiger, and John Lissauer. Also thanks to Leonard's manager Robert Kory for giving me the OK on the book; "We encourage you in your work" was a very reassuring comment.

The following books were also useful;
I'm Your Man, by Sylvie Simmons
Leonard Cohen on Leonard Cohen, by Jeff Burger
The Lyrics of Leonard Cohen
Songwriters on Songwriting, by Paul Zollo

And these films;
Bird on A Wire
Ladies and Gentlemen, Leonard Cohen
The Song of Leonard Cohen
I'm Your Man

The following websites are also essential for any Cohen addict and they deserve special mention here;
Leonard Cohen-prologues
The Leonard Cohen Files and Forum
Cohencentric

ABOUT CHRIS WADE

Chris Wade is a UK based writer and musician. As well as running the acclaimed music project Dodson and Fogg, he has written books on The Kinks, Captain Beefheart, Robert De Niro, Madonna, Frank Zappa and many more. He's released audiobooks of his comedic fiction, narrated by such actors as Rik Mayall and his other projects include Rainsmoke, a musical recording project with actor Nigel Planer, and Hound Dawg Magazine.

More info at his website: wisdomtwinsbooks.weebly.com

www.ingramcontent.com/pod-product-compliance
Lightning Source LLC
Chambersburg PA
CBHW060903170526
45158CB00001B/481